# CAPE DORSET SCULPTURE

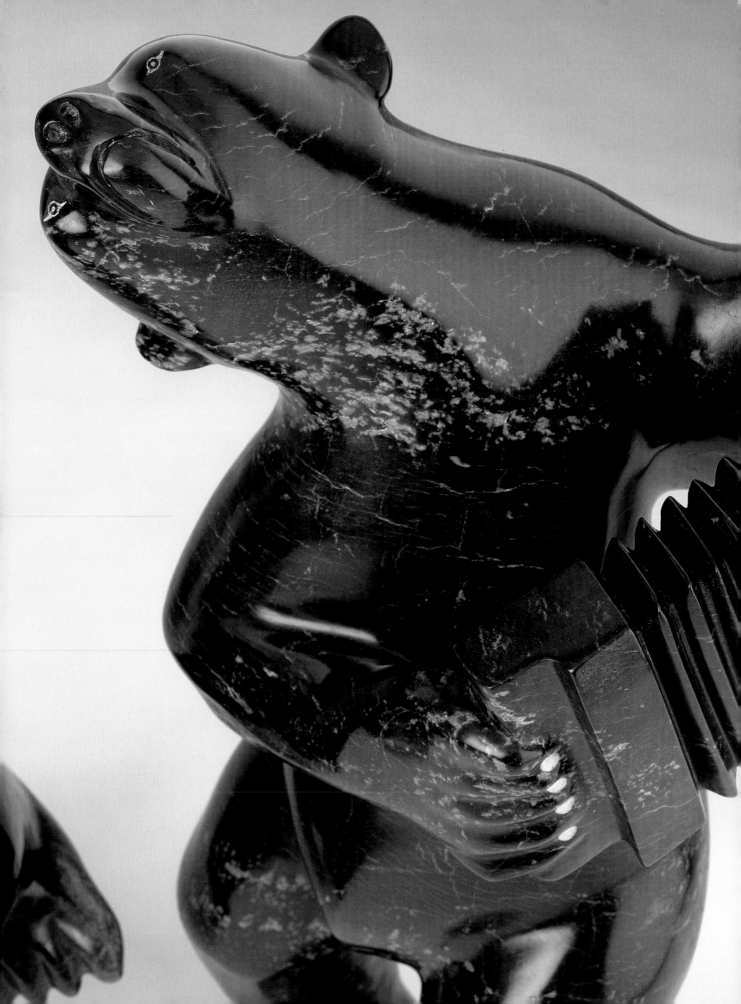

DEREK NORTON

NIGEL READING

# CAPE DORSET SCULPTURE

*introduction by* TERRY RYAN

*photographs by* KENJI NAGAI

DOUGLAS & MCINTYRE
VANCOUVER/TORONTO

UNIVERSITY OF WASHINGTON PRESS
SEATTLE

Copyright © 2005 by Spirit Wrestler Gallery
Introduction copyright © 2005 by Terry Ryan
Artworks copyright © 2005 by the individual artists

05 06 07 08 09  5 4 3 2 1

Originated and published in Canada by:
Douglas & McIntyre Ltd.
2323 Quebec Street, Suite 201
Vancouver, British Columbia
Canada  V5T 4S7
www.douglas-mcintyre.com

Published in the United States by:
University of Washington Press
PO Box 50096
Seattle, WA 98145-5096, U.S.A.
www.washington.edu/uwpress

Editing by Saeko Usukawa
Cover and interior design by Peter Cocking
Front cover: *Bird Shaman Transformation* 2002, by Ashivak Adla
(1977– ), serpentine, 7½ × 5½ × 2 inches; photograph by Kenji Nagai
Back cover: *Dancing Walrus with Clam* 2002, by Aqjangajuk Shaa,
RCA (1937– ), serpentine, antler, 15 × 15 × 11½ inches;
photograph by Kenji Nagai
Printed and bound in Canada by Friesens
Printed on acid-free paper

All photographs by Kenji Nagai, except where credited separately
All measurements are in inches in the order of height × width × depth

Frontispiece: *Shaman's Celebration* 2002, by Quviantuliak Takpaungai
(1942– ), serpentine and antler, bear 32½ × 16 × 14 inches

*Library and Archives Canada Cataloguing in Publication*
Norton, Derek
   Cape Dorset sculpture / by Derek Norton and Nigel Reading ;
   introduction by Terry Ryan ; photographs by Kenji Nagai.
   Includes bibliographical references.

   ISBN 1-55365-088-3

   1. Inuit sculpture—Nunavut—Cape Dorset.  I. Reading, Nigel,
1948–  II. Title.
E99.E7N68 2005    730'.89'971207195    C2004-906461-4

*Library of Congress Cataloging-in-Publication Data*
Norton, Derek.
Cape Dorset sculpture / by Derek Norton and Nigel Reading ;
introduction by Terry Ryan ; photographs by Kenji Nagai.— 1st ed.

   p. cm.
   Includes bibliographical references.
   ISBN 0-295-98478-3 (pbk. : alk. paper)

1. Inuit sculpture—Nunavut—Cape Dorset.  2. Stone carving—
Nunavut—Cape Dorset.  3. Inuit artists—Nunavut—Cape Dorset.
4. Inuit—Nunavut—Cape Dorset—Social life and customs.
5. Cape Dorset (Nunavut)—Social life and customs.
I. Reading, Nigel.  II. Title.
E99.E7N68 2005    730'.89'9712071952—dc22    2004023553

We gratefully acknowledge the financial support of the Canada Council
for the Arts, the British Columbia Arts Council, and the Government
of Canada through the Book Publishing Industry Development Program
(BPIDP) for our publishing activities.

# CONTENTS

WE AT THE SPIRIT WRESTLER GALLERY extend our congratulations to all the artists for their outstanding work and for sharing insights into their world. Individually, the works are outstanding: together, they are magnificent.

We asked the artists to say a few words about their work: some had thoughts that they wanted to share, though some felt that their works were self-explanatory; and others, given the difficulties of language (and sometimes health), simply were not able to make a statement. We are grateful to them all for their co-operation.

We thank the many people who contributed to this project, particularly Terry Ryan for his informative introduction about Cape Dorset; we very much appreciate the time he devoted to this from his busy schedule. There is no one more knowledgeable than he to write on Cape Dorset.

Our thanks also to the West Baffin Eskimo Co-operative for their continued assistance in creating this book that documents the transition of the arts of Cape Dorset. We are grateful to Jimmy Manning and Chris Pudlat in Cape Dorset for all their support over the years, and again to Terry Ryan for permission to publish his archival photographs of the community. We would especially like to thank John Westren at Dorset Fine Arts in Toronto for his valuable guidance in building this collection.

We are fortunate to have had Kenji Nagai as our photographer for capturing the essence of the sculptures with these extraordinary photographs. It has been a privilege working with him on so many projects over the last fifteen years.

We thank Scott McIntyre of Douglas & McIntyre for his encouragement of this project, Saeko Usukawa for her editing and Peter Cocking for his design of the book.

The Spirit Wrestler Gallery—Nigel Reading, Derek Norton, Gary Wyatt and Colin Choi—thank our respective partners, Judy Nakashima, Donna Alstad, Marianne Otterstrom and Christine Huang for their continued belief and support.

We would like to dedicate this book to the memory of a long-time collector and supporter of the arts, our friend Gordon Cooper. His fifty years of collecting, his eye, his passion and his enthusiasm for art were a lesson for us all. Saturdays without Gordon—and his delicious sticky pastries—are simply not the same.

# INTRODUCTION: LOOKING BACK AT CAPE DORSET

TERRY RYAN

HAVE BEEN INTRIGUED by Canada's Far North since graduating from the Ontario College of Art in Toronto in 1954. Inspired by the work of one of my professors, George Pepper, I wanted to see and to paint this distinctive Canadian landscape, but getting there proved to be much more difficult than I anticipated. There were no commercial carriers back then and no one went North without a specific purpose; in short, a job and accommodation. So in order to fulfil my youthful artistic ambitions, I took a training course in radiosonde meteorology and then managed to get myself posted to the weather station in north Baffin Island. Aboard the government medical supply ship *C.D. Howe*, I travelled to my destination near the present-day community of Clyde River in 1956.

In 1960, after two years in Clyde River and a sojourn in neighbouring Greenland, I began what turned out to be a lifelong association with the community of Cape Dorset. At the time, James Houston was the resident area administrator, working for the federal government's Department of Northern Affairs. I had already met and corresponded with Jim in 1954, shortly after my Ontario College of Art days. We'd met again in the fall of 1958 in Cape Dorset, when I was en route south from Clyde River; he was off to Japan to study printmaking techniques, and I was on my way back to Toronto. Interested by his early efforts to develop art among the Inuit, I was determined to find a role for myself, but several attempts to locate accommodation in the Arctic proved unsuccessful. My options seemed to be a career with the Hudson's Bay Company or the Royal Canadian Mounted Police (RCMP), and neither held sufficient appeal. One final effort to travel to Ennadai Lake in the Keewatin area failed due to the restricted accommodation at the weather base there.

I moved back south to a prospective position with the Victoria Art Gallery on Vancouver Island, equipped with a letter of introduction from another Ontario College of Art instructor, Jock MacDonald. My Arctic ambitions thwarted (or so I thought), I found a studio but barely had time to settle in before I was notified of a summer position at Cape Dorset working with Jim Houston. With some hesitation, I returned east and found myself once again aboard the *C.D. Howe*, bound for Cape Dorset.

Jim had become interested in Inuit carvings on his first visits to the Arctic in 1948 and 1949, and since that time had worked for the Canadian Handicrafts Guild and the Canadian government to promote Inuit crafts. He had submitted his ideas

on ways to encourage Inuit art and artists to Ben Sivertz, then the director of the federal Department of Northern Affairs and Natural Resources, and their discussions resulted in Jim's appointment as a northern service officer with the department. He and his wife, Alma Bardon, and their two young boys, John and Sam, took up residence in Cape Dorset in 1956 and began the work of encouraging and developing the arts and crafts of the local Inuit. In spite of his myriad responsibilities and distractions as area administrator, Jim worked to enable the federal government to provide an early stimulus that proved instrumental in introducing Inuit art to a worldwide audience.

Jim and Alma were there to greet me on my arrival in Cape Dorset, and their welcome was warm and casual, as all things north of 60 were at the time. They showed me to my accommodation—the winter home of Kananginak Pootoogook—who had made it available to me, as he and his family were moving back to the land for the summer months. It was a small, one-room building, colloquially referred to as a "rigid frame," and when I opened the door, I saw to my astonishment that the entire room was painted silver—walls, floor and ceiling! I felt like I was stepping into a foil container. I later learned that the hospitable Kananginak had wanted to make sure his small home was neat and clean for his guest from the south, but the only paint available in town was, for some reason, silver.

Cape Dorset, nestled in a small cove on the southwest extremity of Baffin Island, consisted, at the time of my arrival, of the ubiquitous Hudson's Bay Company post, fewer than a dozen small houses for the Inuit, a one-room school, a small nursing station (formerly the Baffin Trading Company post), a soon-to-close Catholic mission and the Anglican Church building. And, ever so picturesquely, several dozen large white circular tents dotted the rocky shoreline to accommodate those families visiting in town for "ship time," the annual visit of the supply ship.

Beside Jim and Alma's house, the largest residence in town, was a small building (it looked like an enlarged shoebox) that Jim used as his office and also to store stone carvings. I marvelled at the small collection of sculptures that lined the shelves, but it was during my subsequent visits to the many outlying camps that I was truly struck by the talent of these Inuit artists. There, I had the extraordinary opportunity to observe men and women take up a piece of stone and—when the spirit moved

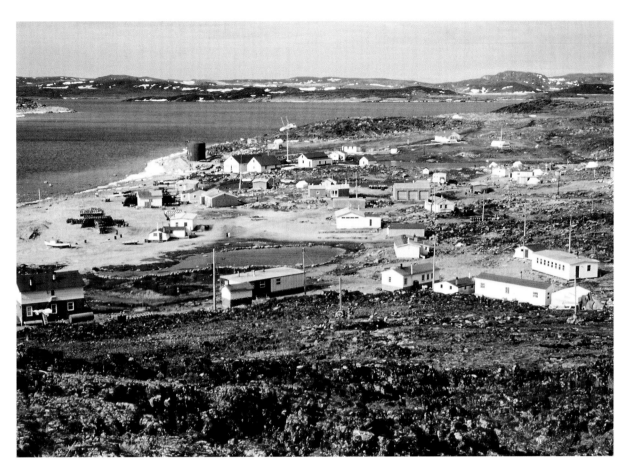

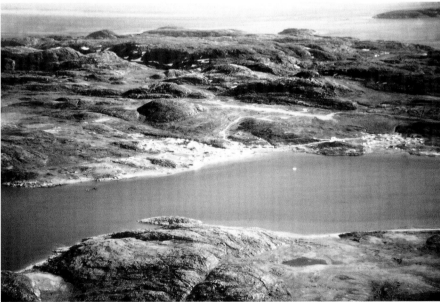

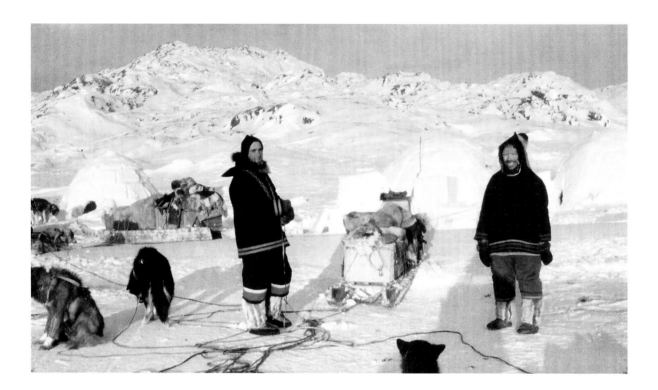

them and they were able to take time from their more pressing needs to find sustenance by hunting, fishing and gathering—to carve.

Well before my arrival, the rudiments had already been put in place to encourage the development of the arts in Cape Dorset. A one-room building, referred to as a "512" (denoting the square footage), housed the fledgling arts and crafts activity. Jim and Alma were determined to find the ways and means to involve the Inuit in expressing their artistic talent, and, at the same time, Inuit art was gradually becoming better known. This was largely because of the early distribution efforts of the Canadian Guild of Crafts and the Hudson's Bay Company, through its network of southern stores. Some of the missions and missionaries also played a part in bringing carvings out of the North, as did other interested individuals such as RCMP officers, traders and, in due course, the first teachers. The most important factor in the growth and marketing of the art, however, was the co-operative movement and the dealer network that gradually formed around the sustained efforts of the co-ops to supply and promote quality work.

In the late 1950s and early 1960s, as more people began to leave behind their nomadic ways and move into settlements, the government helped to establish Inuit-owned co-operatives across the North to provide income, employment and services to their growing communities. The first co-op in the Baffin region was formed at Cape Dorset in May 1959 as the West Baffin Sports Fishing Co-operative, with

the aims of developing tourism and trade in natural resources. The name was changed in March 1961 to the West Baffin Eskimo Co-operative Ltd. (WBEC), and its efforts were concentrated on the arts. Carving was becoming more important as a source of income for many families, and, by 1960, the graphic arts of the Inuit had been introduced to a small but enthusiastic audience. There was much to build on.

That year, I became the first non-Inuit hired by an Inuit-owned association—initially as the arts advisor and secretary to the board of directors, and later as general manager. The West Baffin Eskimo Co-operative is wholly owned by its members, all of whom are residents of Cape Dorset and almost all of whom are of Inuit descent. From its modest beginnings as a seasonal tourist camp, the co-op has grown enormously over the years. Today, it operates retail grocery and supply stores and administers government community service contracts, providing essential services such as the home delivery of heating fuel and gasoline. Its most enduring contribution, however, to both the community and the world beyond, has been the development and success of Cape Dorset's carvers and graphic artists, and the distribution of the work produced by this extraordinary group. In the early years, the WBEC assisted in setting up Canadian Arctic Producers, a co-operative marketing body in the south, for the orderly distribution and sale of Inuit art and crafts from communities across the Canadian North. Now, the WBEC independently markets the works of its own members under the name of Dorset Fine Arts.

LIFE IN THE ARCTIC has changed greatly since I first arrived in the 1950s. Back then, most Canadians regarded the North as a distant and inaccessible place, and to the Inuit the south was truly a mystery. In many respects, that isolation enabled the Inuit to live unencumbered by outside influences and pressures. In those days, it wasn't unusual to find an unfinished sculpture simply left on the beach to be taken up again hours, days, weeks or even a whole season later. I can recall visiting camps vacated by their inhabitants (who had left to hunt or gather berries) and noticing sculptures in progress amid the flotsam and jetsam of rifles, harpoons, nets and the occasional seal carcass.

In the months and years and decades after my arrival, I became increasingly aware of the singular relationship between carver and carving. Individual

*Facing page:*

An Inuit campsite with igloos on mid Baffin Island (Terry Ryan on left and Simonie on right), circa 1964. TERRY RYAN PHOTO

*Facing page, top left:*

Latcholassie Akesuk
(1919–2000)
**Owl Spirit** C. 1970
serpentine · 15 × 11 × 9 inches
Private Collection

*bottom left:*

Sheokju Ohotok
(1920–1982)
**Weasel** C. 1980
serpentine · 3½ × 15 × 2 inches
West Baffin Eskimo
Co-operative Collection

*top right:*

Kiawak Ashoona, RCA
(1933– )
**Woman with Fish** C. 1982
serpentine · 17 × 10 × 8 inches
West Baffin Eskimo
Co-operative Collection

*bottom right:*

Mary Kudjuakjuk
(1908–1982)
**Owl Spirit** C. 1970
serpentine · 4½ × 7 × 3 inches
West Baffin Eskimo
Co-operative Collection

personality imbued the work of many carvers, to the extent that their pieces could not possibly have been made by anyone else. I was also intrigued by the variety of sculptural styles among a relatively small group of people and impressed, too, by the consideration and respect generally shown by artists for each other's work. The effort involved was always acknowledged, the occasional sarcastic comment notwithstanding.

Latcholassie Akesuk and his father, Tudlik, would envision their creations in a most simplified and stylized manner, as did Mary Kudjuakjuk and others. At the other extreme, Osuitok Ipeelee and Kiawak Ashoona, along with Sheokju Ohotok, created truly representational and detailed works with great skill. Regardless of style, these sculptures captured the spirit of the times, reflecting each maker's unique sensibility and way of seeing the world.

The connection between the artist and the buyer was also close. A typical scene would take place when a dog team and *kamoutik* (sled) arrived from a distant camp, weighed down with members of the family and skins for trading. Sons and daughters unloaded a large bundle and carried it into the buying room while the father entered to shake hands and inquire about community news. Then they carefully unrolled the bundle of sealskins onto the floor, and there it was, a stone masterpiece. At other times, quiet, unassuming regulars would wait patiently, sometimes for hours, for me to return from other co-op duties or from the preoccupations of my periodic role as justice of the peace and coroner, and then unwrap a small stone carving whose artistry took my breath away.

There were also occasions when I had the opportunity to engage in a more jovial relationship with the sculptors, men and women who were my friends and neighbours. One of these regretfully backfired on me. Kiawak Ashoona once presented me with a lovely small piece of sculpture, which I truly appreciated. While he was distracted in conversation with another artist, I stepped outside the building, ostensibly to better view the work. Instead, I placed the carving out of sight, picked up a rock of similar size from the roadside and heaved it at a rock face, where it exploded with a loud bang. Kiawak reacted with startled horror; he thought I had lost my mind. Needless to say, I was quick to explain my action, but however humorous I thought it was, my naive attempt to deceive him was not appreciated (not to mention the

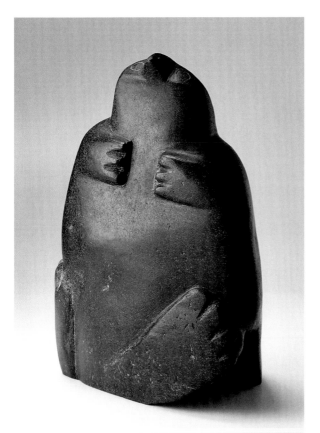

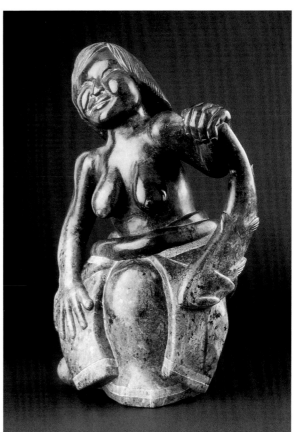

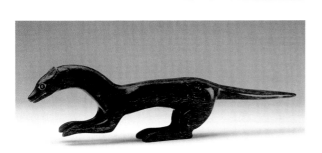

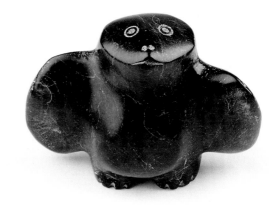

implication that his sculpture wasn't worth much). In defiance, he retrieved his fine piece of work and marched away to find another buyer at the Hudson's Bay Company. Kiawak did return to the co-op fold, but he kept a wary eye on me during all future negotiations.

Some elders, like the late Kiakshuk (who was rumoured to be a shaman), and others like Peter Pitseolak and Kingwatsiak, had a very commanding presence when they presented a carving for viewing, and they took considerable time to explain it and to enlighten me about the significance of a finished work or a work in progress. Among the women who carved, Mary Kudjuakjuk in particular also had this presence, this inner strength. I was expected to take note, to listen to the explanation of what was being offered and to appreciate that work with due respect. It was an extraordinary time, and those of us who had the opportunity to be there were engaged in a rare, once in a lifetime experience to understand and encourage this wonderful process.

The Arctic landscape that so influenced these people merits some comment. Southwest Baffin Island, overlooking the Hudson Straits, is a beautiful place. The hills rise to approximately 1,000 feet, undulating and broken by deep fiords. Extreme tides create a daily contrast between sea and land. The colours in all seasons, including the cold winter months, are truly startling: deep mauves, brilliant blues and aquamarines, as well as indescribable shades of white on white. The fall months bring a more subtle palette, similar to the fall colours in eastern Canada but without the foliage, there being no trees on Baffin. Instead, the tundra and the lichen take on the deep reds, the golds and the amber tones of autumn.

The landscape certainly impressed me, and in my early years in Dorset, I painted the surrounding countryside. On one such excursion, some new-found Inuit friends were eager to accommodate me by providing transportation by boat to an outlying island in the Hudson Straits. They dropped me off on a fine Friday evening in midsummer, and equipped with food, tent and gun, I revelled in the opportunity to have several days to myself, to both paint and explore. The island is called Sakkiak, and it is well known for its association with the legend of a man called Tiktaliktak, who found himself stranded there some fifty years before. The story goes that he nearly succumbed to depression but rallied, after a dream vision, to make a raft from seal

bones and seal bladders; and so he eventually made his way back to the mainland and his grieving family, who had given him up for dead.

As the weekend progressed, I thought a great deal about this brave man's ordeal, but I was enjoying my time alone and engrossed in my uninterrupted painting. By Sunday night, I had fulfilled my plans and savoured the meals from my supplies. Typically, I had brought along far more food than was required for one weekend, a fact that my guides had commented upon when they left me. Fortunately, my overstocked larder proved providential, as I was not picked up until the following weekend. I spent a fretful week pondering not only the old legend but also worrying about the possibility that my friends had had a mishap themselves and had not returned safely to Cape Dorset, in which case no one would know of my whereabouts. When they finally arrived to collect me, they laughingly claimed that this was my own dictate—compounded by my limited knowledge of speaking Inuktitut, then as now. I often wondered whether the mistake was mischievous on their part or was indeed a simple error in communication. I remained from that day forward ever cautious in planning trips alone or with others.

IN THE EARLY YEARS, when Inuit carvers made a rare visit down south, they liked to go around and look at other shows. I was frequently surprised by their reactions to works about which we assume everything has been said. They often picked up on nuances that we missed, revealing their different priorities and ways of looking at things. At one show, a United Nations exhibition in New York, a curator noticed that two sculptors from Cape Dorset were deeply involved in a discussion in front of a large framed oil painting. When the curator asked their opinion of the well-known painting, the carvers expressed real admiration and respect for whoever had made the ornate frame. The frame was an early piece of masterwork carving, and the two men were intrigued and very impressed by all the work done on it.

Cape Dorset carvers have become well known for the very naturalistic forms of animals and dramatic compositions that they carve from a particular green stone. This local serpentine stone, which actually ranges in colour from light yellow-green to black, has qualities that allow the artist to carve fluid forms, daring and delicate lines and achieve smooth, elegant finishes. Stone for carving was always difficult

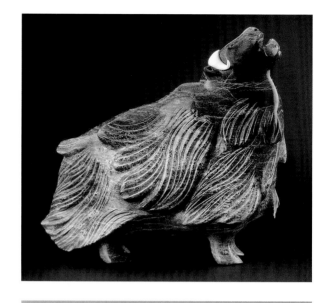

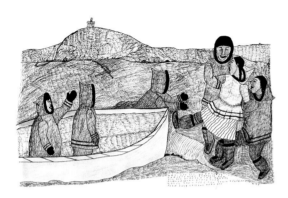

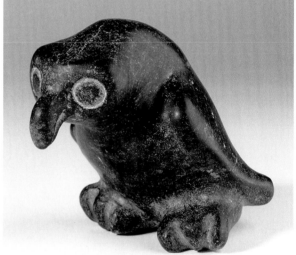

to procure, however, though nowhere near as difficult as in some other Arctic locations. At first, artists made summer trips to those areas where they traditionally had gone to collect stone used for making *kudliks* (seal-oil lamps) and other small utensils. Soon, however, they were on the lookout for new sites that might provide a supply of stone they could use for carving. Cape Dorset carvers were fortunate because there were a number of sites, albeit many miles east of the settlement, that provided a selection of stone with different degrees of hardness and in a range of colours. Although granite was used on occasion for small pieces, a more workable stone would allow the artist, using the basic tools available (hatchet, file and sandpaper), to bring to fruition the images that they envisioned. Carvers who preferred a realistic style were drawn to the softer rock, whereas those who envisioned the stylization of simpler forms chose the harder varieties.

The amount and weight of stone that could be transported from the quarries was limited by the size of the freighter canoes favoured by the hunters. Fortunately, the number of people who owned boats that could make the trip to the more distant sites gradually increased in number. The Hudson's Bay Company had a large Peterhead boat, and so did Paulassie Pootoogook and his uncle, Peter Pitseolak. These vessels could accommodate about 12 tons of stone each, but we never filled them to capacity, fearing the ever-present possibility of turbulent waters on the return trip. Finally in 1970, the co-op purchased a 42-foot, diesel-powered boat previously used by the RCMP. It was originally named the *Belcher* (after an RCMP inspector), and we held a local competition to rename the boat, deciding on the *Arluk* (killer whale), which was Peter Pitseolak's submission. For many years after, a fleet of boats led by the *Arluk* travelled to the distant quarries to bring back significant quantities of stone.

For a period of time, I was the licensed "powder-monkey," drilling and blasting the overburden to expose the preferred stone below. The blasting proved to be a mixed blessing, however, as the dynamite often fractured the stone beyond use or weakened the structure of the matrix. Traditional methods prevailed, and to this day blocks of stone are still pried and worried out of cliffsides and open pits, laboriously carried to the beach and transferred to a canoe, then taken out to a larger vessel and transported back to Cape Dorset. Although new tools have been made

available to aid in the quarrying of the raw stone, the whole procedure is still back-breaking and dangerous, and accidents have happened, a few of them fatal.

New tools have also entered into the carving process. Although it is true that the intrusive nature of power tools can sometimes seem to dominate the artistic vision, their capabilities can also enhance the work and the possibilities, allowing carvers to use harder stones like granite and marble that were considered nearly unworkable in the past.

THE WEALTH OF TALENT and imagination of Cape Dorset's artists has earned the community a reputation as a vibrant arts centre, not only for sculpture but for the graphic arts as well. The development of the graphic arts gave women in particular the opportunity to shine, as many of their early drawings echoed the skin appliqués they used to adorn parkas, boots and other clothing.

The co-operative began to purchase drawings in the late 1950s in order to build an image bank for the printmaking studios. At first, most of the drawings were made by people living outside the community in the many outlying camps. When they came in to trade furs or buy supplies, they also visited the co-op to sell their carvings or other craft items; and when they left, they were encouraged to take with them a roll of drawing paper.

Kenojuak Ashevak, who is now a world-famous Canadian Inuit artist, was one of the early participants, and she revelled in the opportunity to draw and in the enthusiastic response to her work. She would accompany her husband, Johnniebo, from their camp a few miles east of Cape Dorset, to present her finished drawings and to marvel at the colourful prints made using her images. Others took to the task more hesitantly and were appreciative of the patience and interest that we—the printmakers and I—showed in their development as graphic artists. It was all very lively when several families would arrive with their dog teams and, after visiting overnight with relatives, come to the studio to present their creations. Much laughter and good-hearted banter ensued over who had done what, and if a story or legend was depicted, others commented or elaborated on it.

By the late 1960s, the graphic studios had attained an enviable reputation and an eager audience for original prints. The initial small staff of Kananginak Pootoogook,

Eegyvudluk Pootoogook, Lukta Qiatsuk and Iyola Kingwatsiak were followed by others who undertook the precise work of transcribing a drawing to the surface of a stone block, carefully cutting and incising the details, then inking and editioning a series of prints. This process—the stonecut and its variations, including stencil—was the established one in the early years. Given my particular interest in print-making and in expanding the capabilities of the studios, etching and engraving were added in the early 1960s, and serigraphy followed as we developed another craft project in fabric printing. This exciting but limited venture led to the creation of some wonderful fabric designs, examples of which graced Canada's national pavilion at Expo 67. Lithography was introduced in the early 1970s, with the first press purchased from well-known Toronto artist Charles Pachter, who also provided the first type fonts for the typography project. Toronto art dealer Av Isaacs was instrumental in these transactions and was one of the early and enthusiastic supporters of that art form. In fact, the list of well-known Canadian artists and others in the southern art world who have been involved in some way with the print studios in Cape Dorset is extensive and impressive. Many came to provide technical training; all came to partake of the land and its people and to share creative inspiration.

The fabric-printing project was only one of many new initiatives that I tried to put in place as part of my role in managing the growth and development of the co-operative. We also tried ventures in pottery, jewellery and weaving, all in an attempt to interest and engage the members in new forms of expression and to build Cape Dorset into an all-inclusive arts centre. We had considerable success with some of these ventures, in spite of the heavy odds against us, some seemingly within our control and others definitely not. We tried hard to convince first the federal government and later the government of the Northwest Territories to get behind our vision and be consistent with funding, but the limited budgets for the arts had to be shared throughout the region. Cape Dorset had already had its fair portion of success with the printmaking studios and the strength of its sculptors, or so the politics of the day had it; thus, projects that we in fact initiated in Cape Dorset were moved to other places.

Of the factors beyond our control, the most obvious and daunting was simply the isolation of this remote Arctic community. No airstrip was built until the 1970s,

so air travel and air freight were very limited and very expensive. What few flights there were landed on makeshift landing strips on the ice, or on the open bay in front of the community, weather permitting. The annual late-summer visit of the supply ship provided the only opportunity to receive equipment and supplies such as presses, tools, paper and printing inks, and we frequently ran out of materials long before the next supply call. Suffice it to say that building and maintaining a graphic arts studio in the Arctic was a unique and challenging experience.

I had not only the realities of isolation and limited communications to contend with but sometimes the seasonal priorities of the staff as well. A particular memory comes to mind from the early spring of 1970. Sensing the magnetic draw that the returning snow geese were having on the printmakers, I was not totally surprised to have Iyola inform me on a Friday morning that they would not be coming in on the following Monday. Thinking only of the still uncompleted print editions, I immediately called a meeting. I presented my well-reasoned and compelling argument that these unfinished editions would have a direct impact on the annual collection, the design of the catalogue and the bottom line. My audience sat interested and attentive, then thanked me for my instructive discourse. They did not, however, return on Monday, nor for many Mondays to come. They returned only when the geese had departed at the end of the season.

The evolution of the studios and the works created by the artists progressed through many stages of development. Individual egos, social status, age and gender were all factors. In the earlier days, people were animated in their appreciation for the opportunity to develop a new skill, one that also helped them to earn a living. As the years went by and individual reputations grew, a greater sense of entitlement sometimes crept into the transactions between buyer and seller, resulting in some spirited negotiations over the value of a particular piece. Given the structure of a co-operative, all manner of discussions ensued over who owned what and who had the right to evaluate another member's work. The studio staff did not always appreciate an artist's work, and on occasion they could be downright disdainful. This may explain in part why there are so few artists' co-operatives of long standing in southern Canada.

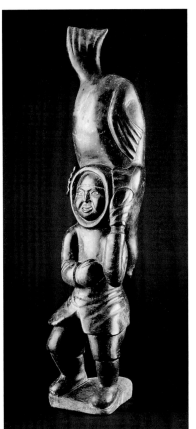

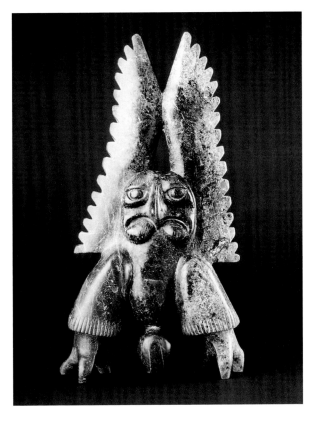

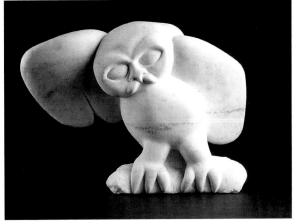

THE SMALL SETTLEMENT of Cape Dorset, first founded in 1913 as a trading post for the Hudson's Bay Company, has come a long way from its beginnings, and the changes that have taken place are profound. The Inuit have left behind their traditional lifestyle, though hunting and fishing still attract the elders and those men and women who look to the land for sustenance, both physical and spiritual. The young people are aware of, but no longer part of, the lifestyle that formed their parents and grandparents. Nevertheless, they strive to retain important elements of their traditional culture—their language, their connection to the land and its resources—while adapting to the new realities of work, school, business and community life.

Inuit art has obviously changed too, and predictions of its demise are still occasionally heard. The tendency to romanticize the earlier way of life plays a part in this thinking, but each generation of artists has its champions, and the present is no exception. Oviloo Tunnillie comes to mind as one of the leading contemporary exponents; her best work is some of the most powerful to come out of the new North and displays a keen sense of social commentary. Napachie Pootoogook's drawings are also poignant social commentaries that illustrate the stories told to her by her mother and older brother, Namonai. Many of them deal with the crueller aspects of camp life, such as abuse and the patriarchal traditions that restricted women's lives.

The older carvers—renowned artists such as Osuitok Ipeelee, Latcholassie Akesuk, Pauta Saila, Qaqaq Ashoona and Paulassie Pootoogook, to name but a very few—paved the way for their sons and daughters and grandchildren to continue the tradition, working in the sheds that are their winter studios or out of doors when the first warm days arrive. But life was very different for this earlier generation: the lack of pressure and the limited distractions afforded them more time for introspection and concentration, as was certainly evident in their work and self-expression. The respectful and appreciative response of the buyers of this early work created a growing desire on the part of artists to communicate with their distant audience, especially their awareness of a passing era. Camp life was disappearing, and the Inuit viewed the future with concern and apprehension. In the directness and tactile appeal of these works, you can feel the force of declarations made with honesty and pride: pride in their craft and pride in their culture.

The wellspring of Inuit art today derives from both an understanding of the past and a reaction to the present. The contemporary art of the North will remain vital as long as there are Inuit artists who are proud of their heritage and who are determined to express their memories, myths and dreams, as well as their feelings and experiences, as they live in their rapidly evolving culture. I see no shortage of younger people willing and eager to do so, providing that support and encouragement are there for them as they have been for their predecessors, who have left an impressive legacy. Probably the most significant legacy is the collection of works on paper: more than a hundred thousand drawings purchased by the co-op over the years illustrate the fantasies, stories, myths, legends and personal memories of so many long-departed friends.

My personal journey through these decades has been truly inspiring. It was not, obviously, a lone endeavour on my part. In addition to the satisfaction of working with such talented artists, I had the support of many others, North and south, Native and non-Native. Their behind-the-scene participation in so many areas was the key to moving this venture ahead, and I am grateful to them all, not only for the legacy left behind in the collections of Inuit art now gathered throughout the world but for my own personal enrichment and gratification in finding myself so involved in such an unexpectedly fulfilling career.

# THE ART AND ARTISTS OF CAPE DORSET

DEREK NORTON & NIGEL READING

FLYING INTO THE TINY HAMLET of Cape Dorset in the Far North of Canada in the winter is, literally, flying into the unknown. You cannot tell the land from the sea or see geographic points to give a perception of scale, because everything is white. The community fronts onto a protected harbour, which is frozen in during the long arctic winters and is accessible by air only when the weather is kind.

Cape Dorset is located north of Hudson Bay on the southwest tip of Baffin Island, well above the treeline and just south of the Arctic Circle. The Inuit inhabitants have always called the area Kinngait (pronounced *king-ite*), meaning "the place of hills," but it was named Cape Dorset in 1631 by the British explorer Captain Luke Foxe, who mapped the region during his unsuccessful search for the Northwest Passage; he named it in honour of the Earl of Dorset, who had sponsored the expedition. Today, Cape Dorset is a modern community of nearly fourteen hundred inhabitants in the newly created Canadian territory of Nunavut.

The Arctic seems a most unlikely location for an arts community, let alone one that has gained an international reputation for its graphics and sculptures, but Cape Dorset has become synonymous with excellence in Canadian art. The story of how this happened is the stuff of legend.

Part of the story lies in the profound and fundamental changes that life in the Arctic has undergone over the last half century. By 1913, the Hudson's Bay Company had set up a post at Cape Dorset to trade for furs with the local Inuit. As the Inuit found the land increasingly unable to sustain the traditional hunting and gathering that they had enjoyed for generations (and as their desire for goods from the south grew), families and hunting groups gradually moved closer to the trading post. Slowly, a community began to take shape.

Canada was a young country then, however, and the focus of development was in the south. After the Second World War, military activity in setting up the Distant Early Warning (DEW) line across the North to protect North America from attack and a boom in the northern mining industry caused dramatic changes. The Canadian government also became concerned that the largely uninhabited land might be annexed by larger powers. This led to the plan to assert Canada's sovereignty by establishing strategically placed settlements. Many of these communities were populated by Inuit encouraged to move there by the Department of Indian and Northern

Affairs, but they often had difficulty relating to their new and different environments with limited opportunities for employment. The ramifications of this policy are still being felt today.

Opening up the Arctic also implied government responsibility to provide the Inuit with the means to become economically self-sufficient. This was particularly difficult in the eastern Arctic, where Cape Dorset is located, as there were fewer resource-based opportunities, so fewer possibilities of wage employment.

At around this time, James Houston, an artist and writer, became interested in the Arctic and made a couple of visits to it in 1948 and 1949, which he found exhilarating. On his second visit, to Great Whale River, he was given a couple of Inuit carvings that fascinated him. He learned that the Inuit had been carving for generations and that in addition to producing amulets, talismans, utensils and tools for hunting, they often made small pieces that had no function, other than that they were pleasing—what today we call art. The Inuit were a nomadic people, taking only what was necessary for survival on a scale that could be transported by dogsled. Later, they carved small pieces to trade with the sailors on ships that were visiting with greater frequency each passing year. The visitors wanted to acquire objects made by people who inhabited one of the harshest environments on earth and the Inuit, in turn, wanted to acquire tools and implements from the strangers on big ships from the south.

James Houston was not the first person to find Inuit carvings, but he is remarkable in that he was one of the first to consider their potential. He also was becoming familiar with the issues and realities of the changing Arctic: the Inuit were coming in off the land and were having a difficult time adjusting to life in settlements, and this, coupled with the lack of employment and language skills, made their prospects tenuous. As an artist himself, Houston recognized the talent of the Inuit and began to think that the production of art could be a way of helping them to become self-sufficient. Very excited, he made connections that led to the first show of Inuit art (as opposed to artifact) at the Canadian Guild of Crafts in Montreal in 1949. During the summers of 1951 and 1952, he and his new wife, Alma, travelled to Frobisher Bay (now Iqaluit) on Baffin Island to encourage the production of handicrafts. Then they embarked on a 260-mile dogsled trek to Cape Dorset to seek out Osuitok

Ipeelee, who was regarded as the best carver in the region. Osuitok responded with enthusiasm and carved many works for Houston, a number of which were shown at the National Gallery of Canada in 1951 and are now considered to signal the birth of Inuit art.

Knowing how difficult it was to make ends meet, Osuitok immediately grasped Houston's idea to help the Inuit and gave it his support. Houston, for his part, realized that he would have to pay cash to acquire pieces so that carvers and their families would have an immediate return for their work. Consigning works to the south and waiting for sales before paying nomadic artists so far away was simply not realistic. Houston also realized that he had to do something to grab everyone's attention, so he decided to pay such a large sum of money for a carving that everyone would hear about it. He paid Osuitok the then princely sum of fifty dollars for a sculpture of a caribou (now in the collection of the Metropolitan Museum of Art in New York). The Inuit were amazed by the amount paid, and this transaction became the catalyst for others to make carvings.

In 1953, the Department of Indian and Northern Affairs hired Houston to undertake fieldwork in the North and to promote Inuit handicrafts in the south. Three years later, he returned to Cape Dorset as a federal northern services officer; his mandate was to explore all avenues of possible economic development, including art-related projects.

Most Inuit still lived in outlying camps, so Houston visited them to encourage people to start carving. The early works were small and essentially narrative: illustrations of family life, often based on the intimacy of living in the close quarters of igloos and tents; depictions of hunting on the land that reflected their deep respect and understanding for the animal world, recognizing them as companions, foes and equals; representations that offered insights into their spiritual beliefs, a complex and often dark world with fantastic beings. Above all, the fact that the Inuit live in a harsh environment that they make easier with a well-developed sense of humour is immediately apparent in their work. Even today, it is rare to see an Inuit piece that does not have humour as a component. These features, as well as the honesty and directness of Inuit art, surprised and delighted a growing and enthusiastic audience that was curious about the North.

In the next few years, there were several critically influential exhibitions: "Eskimo Art" at the National Gallery of Canada in Ottawa, in 1951; "Eskimo Carvings: Coronation Exhibition" at Gimpel Fils Gallery in London, England, in 1953; and "Contemporary Eskimo Sculpture" in 1959 at St. James Church in New York. These shows helped to validate the art to a growing audience and created the first mass awareness of Inuit art.

One particular exhibition that was pivotal to the international acceptance and popularity of the art was "Sculpture/Inuit. Sculpture of the Inuit: Masterworks of the Canadian Arctic," put together by George Swinton and James Houston, and hosted by the National Gallery of Canada. This monumental exhibition offered some 450 works by about 150 artists. After opening in Vancouver in 1971, it toured to Paris, Copenhagen, London, Moscow, Leningrad, Philadelphia and, finally, the National Gallery in Ottawa. The "Masterworks" exhibition included thirty-three artists from Cape Dorset, the largest representation from a single community, and today, eight of them (who are all in this book) are still making art: Aqjangajuk Shaa, Kananginak Pootoogook, Kenojuak Ashevak, Kiawak Ashoona, Kov Takpaungai, Lukta Qiatsuk, Osuitok Ipeelee and Pauta Saila.

STORIES ABOUT THE EARLY DAYS of art-making in Cape Dorset have now become part of the fabric of Inuit folklore and perhaps become more embellished with each telling. One such story is about a conversation in 1957 between Osuitok Ipeelee and James Houston that came to inspire the printmaking program. Osuitok had asked about how the artist dealt with the task of painting the same image over and over again (the sailor on each package of Players cigarettes), so Houston took an incised walrus tusk, inked it and demonstrated the technique of printing by transferring the inked image onto a piece of toilet paper. Osuitok's desire to learn the process led Houston to introduce Japanese woodblock printing techniques to the Cape Dorset artists, but because of the scarcity of wood in the Arctic, they adopted the much older Japanese technique of stone-block printing. However, the variation in the shapes of the stone blocks (and the subsequent problems in the exact registration of additional blocks for each colour) led to the move to the stencil technique. At first, sealskin was used for the stencil templates, but it was abandoned in favour of waxed

paper, a version of which is now used. The tradition of prints being released in limited editions of fifty (still the norm today), stems from the fact that the stone blocks and sealskin stencils both deteriorated with repeated printing. The use of Japanese mulberry paper, which all at the print shop agreed was the best paper to achieve an effective transfer of the ink from the stone, and the "chop mark" system of signing the early prints, came from Houston's experiences in Japan. The 1986 woodcut print *Gathering Kelp* by Kananginak Pootoogook (page 59) illustrates the link with Japan: the image was pulled by Japanese artist Masato Arikushi, using seventeen colour impressions on *kizuki hosho* (Japanese mulberry) paper, in an edition of fifty, signed with Kananginak's chop in Inuktitut syllabics.

Now that a method was in place, the fledging print shop needed images to work with, so the Houstons encouraged many people to try their hand at drawing. The early drawings were by individuals who had no previous experience using pencil and paper, with a few notable exceptions such as Peter Pitseolak, Kiakshuk, Niviaksiak and Osuitok Ipeelee. Many of the great early graphic artists were women, perhaps because of the skills that they had developed with their traditional two-dimensional designs for appliqués on clothing. Drawing offered people the opportunity to give shape to stories that had been preserved in oral histories for many generations, and the elders were particularly encouraged to participate. Their leadership and encouragement of the art program was also critical to interesting the younger generation.

When the first collection of prints was released in 1959, its success proved that here was something that would work. Since then, the Cape Dorset print program, which was the first in the Arctic, has released a collection of prints each year. It became the model for other communities to organize print shops and promote their own artists; many had very successful years but, sadly, most of these have now either closed down or produce prints infrequently.

Having achieved so much in helping to put Cape Dorset on the map, including the incorporation in 1960 of the West Baffin Eskimo Co-operative to help support the arts, James Houston decided it was time to get back to his own work as an artist. Still active today, he continues to act with irrepressible enthusiasm as an ambassador for the promotion of the art of Cape Dorset and of the Arctic as a whole.

Cape Dorset was blessed to have had a man with such passion and vision, but it was even more fortunate to find exactly the right replacement. In 1956, Terrence (Terry) Ryan, a recent graduate of the Ontario College Art, was working at the radiosonde weather observation station at Clyde River on north Baffin Island. He had gone North because he saw it as an opportunity to grow personally and creatively as an artist. On his first visit to Cape Dorset in 1958, he was impressed by the excitement and activity of the fledgling art program. Little did he know that this encounter would be the beginning of a lifelong relationship with the community.

Terry Ryan returned to live in Cape Dorset in 1960 as the arts advisor to the newly incorporated West Baffin Eskimo Co-operative. As an artist himself, he had an appreciative and trained eye, and he shared James Houston's passion for the Inuit and their art. Ryan's continued long-time presence and belief in the Cape Dorset arts community has led to consistency and stability within the co-operative. His vision extended far beyond his management skills, as could be seen in his support for the artists at a personal level that nurtured and sustained their talent. Over time, he put in place a structure for buying artworks and distributing them to markets in the south. Under his guidance, the West Baffin Eskimo Co-operative made a brave move in 1977 by separating itself from the existing distribution system that dealt with all the Inuit co-operatives (except for Arctic Quebec) and establishing an office in Toronto to represent its own artists. Ryan also has been responsible for enlisting art advisors to support various projects in the print and lithography studios. In addition, he has assisted in promoting exhibitions, helped set up significant private and corporate Inuit art collections, and advised on donations to or purchases by prominent museums. His relationships with both artists and galleries have sustained a high level of interest in the arts of Cape Dorset. Without question, much of the credit for the continuance and international recognition of the arts in Cape Dorset must be attributed to Terry Ryan and his forty-five years of dedicated service.

OF ALL THE INUIT COMMUNITIES whose residents began making carvings in the late 1940s early 1950s, what was the stimulus that led to Cape Dorset sculpture achieving such prominence?

For this extraordinary and lasting success, there had to be a spark, tinder and a flame. The spark was James Houston and the tinder was the entire community of artistic talent. The flame thus lit was tended carefully by Terry Ryan. But, more than that, the people of Cape Dorset have a reputation for perseverance and determination to be the best at what they set out to do. As Houston recalled in his introduction to the catalogue *Cape Dorset: The Winnipeg Art Gallery January 12 to March 2, 1980,* "When I first went there in 1951, I found a certain fiery spirit among the people of Cape Dorset, which I think drives a sense of life into their carvings."

A key factor in the success of sculpture from Cape Dorset was the use of the beautiful green serpentine stone available along the south coast of Baffin Island. This, together with the exciting evolution of individual carving styles, made the works immediately identifiable. By the late 1950s, the encouragement and support given by the Houstons (and later by Ryan) allowed carvers to feel comfortable in developing their own styles, which moved away from realistic depiction and towards personal stylization. The continued support from two mentors, both trained in the arts and with developed aesthetics, gave the carvers a freedom that set their work apart from those of other communities. This, in turn, led to another remarkable evolution, the recognition of "name artists." With the freedom to explore beyond the narrative, the carvings from Cape Dorset increasingly became the symbols of a culture, rather than the illustrations of a culture, an approach unique in the Arctic at that time. Today, the successful artists are those who give their carvings not only a sense of life but, perhaps more importantly, imbue their carvings with a sense of themselves.

Another question often asked is: How is it that the talent runs so deep? One answer could be that, in the old days, the ability to make weapons, tools, utensils, clothing, kayaks, sleds and harnesses for the dogs—all from the most basic of materials such as bone, stone, hide and sinew—was an essential survival skill for people who lived on the land. That attitude remains, for the carvers are not romantic about their work; they regard it as a means of survival, an alternative to hunting, particularly during the winter months. Like their parents and grandparents, young Inuit now see art as a way to make a livelihood and choose to follow in their footsteps. As soon as a carving is completed, it is taken to the buyer at the co-operative and sold.

The income generated from carving feeds and clothes the artists' families and helps to provide them with southern luxuries. The affluence the art has provided to the community is readily apparent.

This brings to mind a story about the great carver Qaqaq Ashoona being interviewed for a television show in Vancouver in 1990. He was asked, through an interpreter, if when he looked at a block of stone, he saw a spirit that needed to be released. Qaqaq looked quizzically at the interpreter for a moment, smiled, then explained that he simply looked at the stone and decided what he wanted to carve that day. He did admit that the overall shape or the striations within the stone often influenced the subject matter he chose to portray. When he was then asked if he carved because he felt it was a tradition and legacy passed down to him, Qaqaq replied that he carved for a livelihood. He then said, "If nobody buys my carvings, then the only alternative was to hunt to feed my family!"

Another factor in the more individual artistic styles that carvers in Cape Dorset developed may be that, while buyers in some other communities paid artists by the size of a piece regardless of quality, the West Baffin Eskimo Co-operative paid on the basis of the originality, quality and complexity of a piece. This policy acted as an incentive for artists to produce more inspired work.

Cape Dorset sculpture is directly associated with the beauty of the green stone from which it is carved. The stone is a soapstone, often referred to as serpentine, which can be worked using hand tools. The colour varies depending on the mineral inclusions of iron (magnetite), pyroxine, olivine and brucite that determine both the relative hardness and colour. The artists must often travel great distances, sometimes as far as 190 miles, to collect stone for carving from established quarries. In 1976, deposits of white marble, sometimes with pink hues, were discovered near Cape Dorset, but its hardness does not lend itself to detail like the serpentine.

SINCE THE NEW MILLENNIUM witnessed the formation of the Inuit territory of Nunavut, it seemed the right time to present this collection in order to display to the world the renewed optimism emanating from Cape Dorset.

One of the joys of this collection is that a number of the artists who were a part of the early days of art-making in the community are still alive and creating—and this

book honours them. Many of them have attained the highest awards that Canada can bestow and have received worldwide recognition for their work. To date, thirteen artists from Cape Dorset have been elected to the Royal Canadian Academy of Arts: Abraham Etungat, Pitseolak Ashoona, Pauta Saila, Kenojuak Ashevak, Osuitok Ipeelee, Kananginak Pootoogook, Mayureak Ashoona, Kiawak Ashoona, Paulassie Pootoogook, Toonoo Sharky, Pitaloosie Saila, Aqjangajuk Shaa and Oviloo Tunnillie. Ten of these artists are included in this book.

A number of artists also have been honoured by having their works portrayed on Canadian stamps, and their sculptures and graphics have been presented to royalty, popes, presidents and heads of state. Many artists have been featured in solo and group exhibitions internationally, and their work has been acquired by art galleries and museums around the world, an extraordinary level of achievement for a small Arctic community.

Today, a memorial cairn stands on a hillside above Kinngait to honour three of Cape Dorset's early leaders—Ashoona, Pootoogook and Saila—whose arrival, with their hunting groups, is now considered the start of the community and the beginning of a new time for the Inuit. The depth of respect for them is evident in the words engraved on the cairn:

> Pootoogook was a born leader. He came from a respected family and he gained more respect through his skill as a hunter. Early in life, Pootoogook accumulated wealth in the form of hunting gear and boats from trading with the Hudson's Bay Company. This combination of wealth and respect made him a natural leader.
>
> Pootoogook began to represent his camp of up to 40 relatives and followers in its dealings with the HBC. As leader, he had to maintain the fine balance that existed in the relationship between the HBC and the Inuit.
>
> A leader like Pootoogook existed in every Inuit camp throughout history. Followers depended on them to look after their interests, to know when and where to move camp, and to make decisions that the whole camp relied on for its survival.
>
> In modern times, however, leaders have had to take on a new role, that of dealing with the *qallunak* (southerners). This has put a greater emphasis on the need for diplomacy, and an understanding of more than the Inuit's own culture. Such

leaders as Saila at Nurrata west of here, and Ashoona at Igalallilk to the east, were among the first to take this challenge. Today they are remembered for their ability to successfully lead their people into a new era.

Years later, these three founding leaders' descendants—whom we know as the artists Pauta Saila, Kiawak Ashoona, Paulassie and Kananginak Pootoogook—are all active artistically and are politically important in the community. So are the descendants of three other great hunter/carvers: Kiakshuk, Niviaksiak and Joe Jaw.

Works by many of the older artists have greatly influenced the look and direction that the art has taken over the last fifty years. There is the joie de vivre and exuberance of the classic *Dancing Bear* by Pauta Saila (page 105), now the oldest male resident in Cape Dorset, and the monolithic power of *Owl Spirit* (page 118), one of the last sculptures completed by Osuitok Ipeelee before he reluctantly retired from carving. The genius of Kiawak Ashoona, now the last of the dynasty of the sons and daughters of Ashoona and Pitseolak, is evident in two of his intricate sculptures, *Legends* (page 120) and *Girl Braiding Her Hair* (page 36). The changes taking place in the North are revealed in two sculptures of life on the land by Paulassie Pootoogook, the traditional *Hunter Packing Heavy Load* (page 72) balanced by the modern *Man on Ski-Doo* (page 40). His younger brother, Kananginak Pootoogook, is a master of both graphics and sculpture, and he is represented in this book by his stylized *Windswept Muskox* (page 85), as well as by a print (page 59) and a drawing (page 90).

A book about Cape Dorset art would not be complete without including the renowned Kenojuak Ashevak. From the very first, she was a stalwart of the annual print collections with her essential contribution, as illustrated in the 1997 signature copper-etching *Guardian Owl* (page 58). Her 1960 print, *The Enchanted Owl*, has become an icon of Canadian art, appearing in numerous publications and on a Canadian stamp. During the last few years, she has retired from carving, but one of her sculptures from the late 1980s is included here.

This book, *Cape Dorset Sculpture* is about living artists. Not all of the senior artists are still producing art, but many of them continue to act as role models and ambassadors. Their genius has enthralled the world for decades, and their inclusion in this book is vital to provide the living link from the past to the future. Over the last

decade, the baton of leadership has passed to a new generation of artists born in the late 1940s and early 1950s: Nuna Parr, Pitseolak Niviaqsi, Mathew Saviadjuk, Oviloo Tunnillie, Ashevak Tunnillie and Kellypalik Qirmirpik. The relay has continued on to the third generation, particularly Toonoo Sharky, Samonie Toonoo, Jutai Toonoo, Isacci Etidloie and Markoosie Papigatok. Many of these younger artists are from families that were the original makers of art in the Arctic, and they grew up watching the huge influence of art in shaping their community. And now a fourth generation of younger artists is beginning to make its contribution, among them Jamasee Padluq Pitseolak, Ulaiggii Adla, Etidloi Adla and Johnnysa Mathewsie.

Life in the North is in constant transition, and the arts are evolving with these changes. The Arctic is no longer isolated and the days of igloos, dog teams, harpoons, shamans and storytelling have been replaced by houses, Ski-Doos, rifles, Christianity and satellite television—and the artists will eventually come to reflect this adaptation to living in the modern world in their work, without forgetting the vital elements of their culture that they have retained in the way of language and their connection to the land. With the inauguration of the new territory of Nunavut, which now empowers the Inuit with a direct say in their government and their territory, they will be able to develop their culture in their own way.

The first generation of artists in Cape Dorset greatly influenced the world view of the arts from the Arctic, and their art has been vital and strong enough to constantly redefine itself and to inspire succeeding generations. The artists and works in this book were selected in collaboration with the West Baffin Eskimo Co-operative to represent a broad cross-section of inspired stone sculpture from four generations, accented with related graphics, by the recognized elders of yesterday, the leading artists of today and introducing the promising artists of tomorrow.

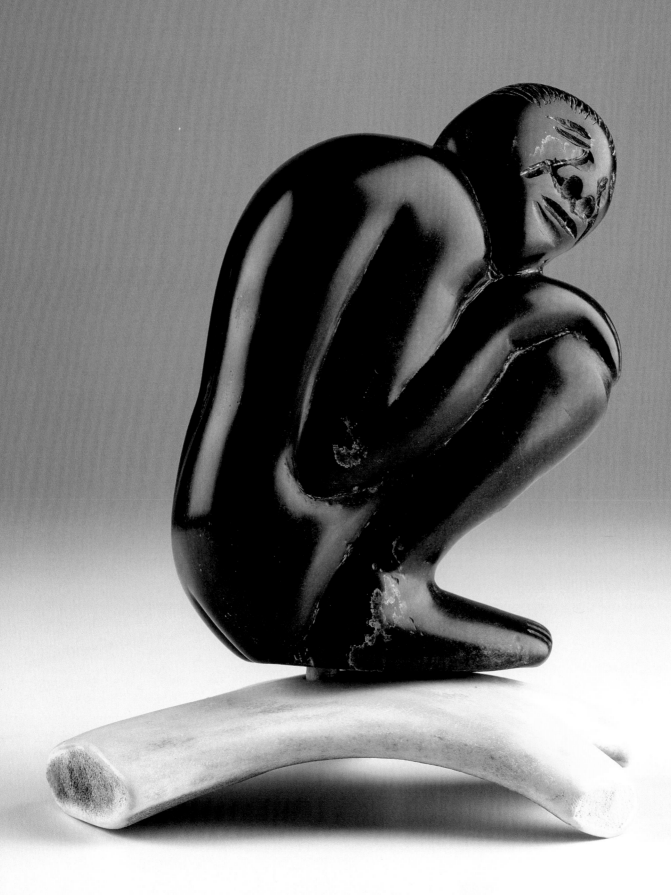

*Facing page:*

**Fears** 2001

Arnaquq Ashevak (1956– )

serpentine, antler

7 × 6 × 6 inches

"When people are afraid,
this is the position that they
end up in. He is very fearful."

# INSIDE THE IGLOO

## LIFE IN THE

## COMMUNITY

## AND HOME

**Mother with Her Child
and Sled Dog** 2003
Pitseolak Niviaqsi (1947– )
serpentine · 15 × 14 × 4½ inches

"Women used to move from
hunting ground to hunting
ground while carrying
their babies. They usually
had dogs for protection
from dangerous animals."

*Facing page:*

**Mother and Son** 2002
Lukta Qiatsuk
(1928–2004)
serpentine
14¼ × 11½ × 6 inches

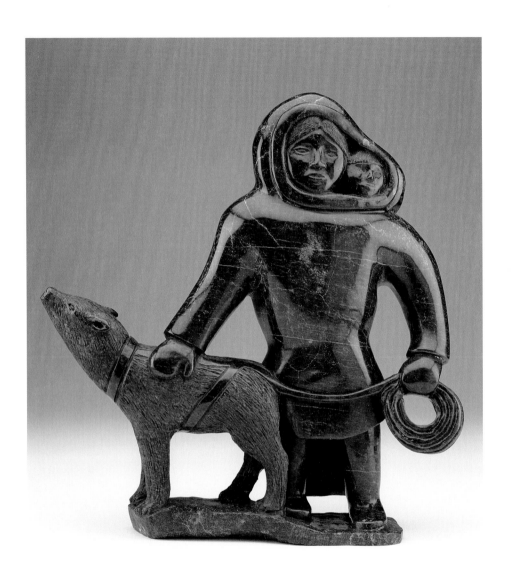

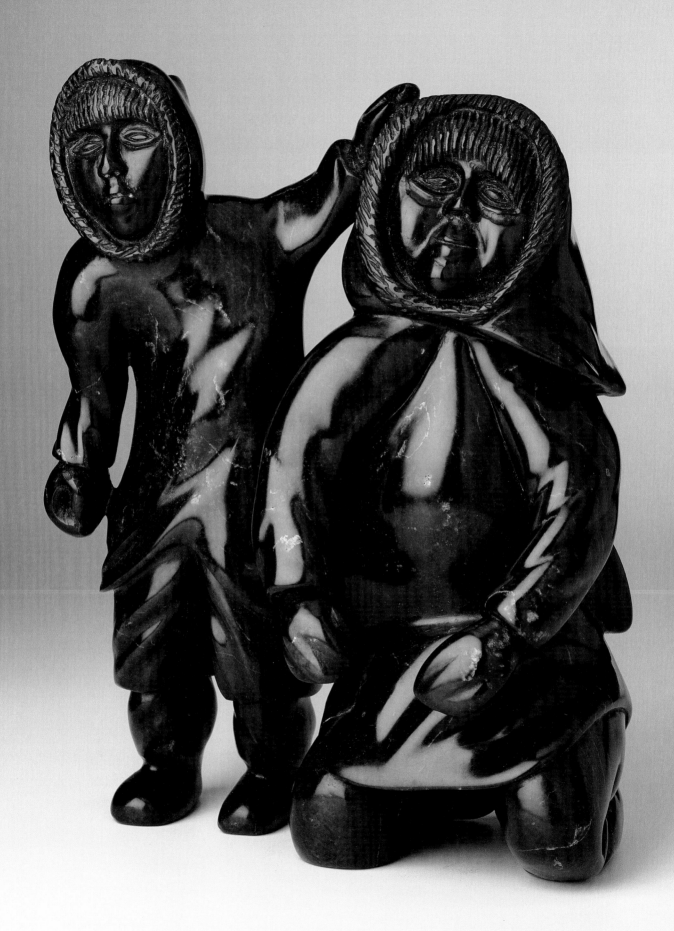

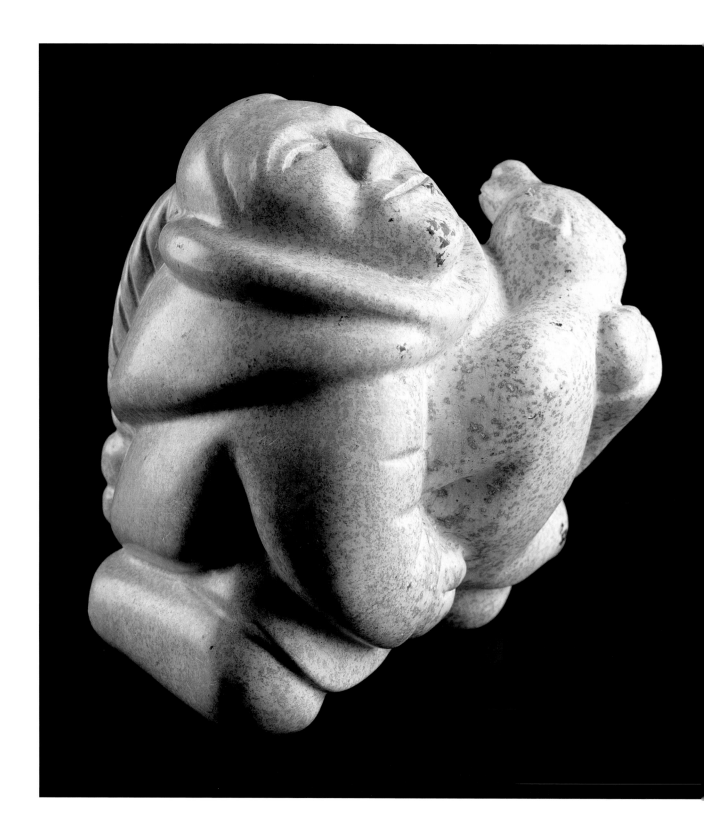

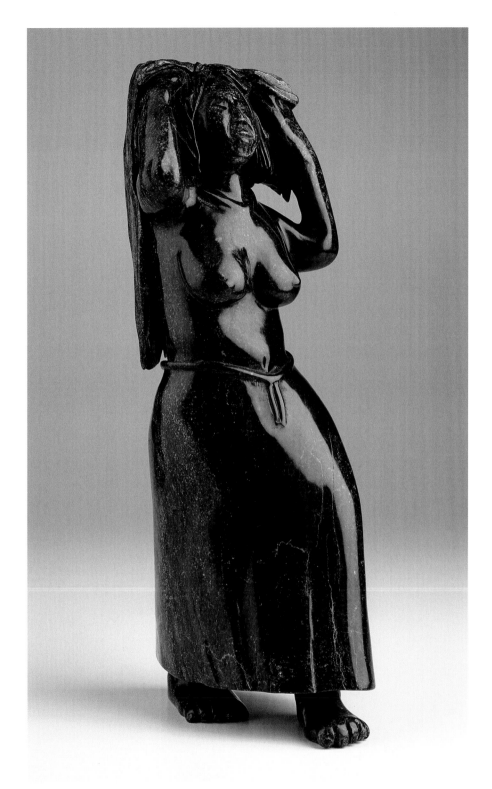

*Facing page:*

**Woman with
Her Dog** 1988
Kenojuak Ashevak,
RCA (1927– )
serpentine · 9 × 7 × 8 inches

"I do remember carving this
many years ago. It is of a
young woman sitting hold-
ing her puppy dog."

**Beautiful Girl** 2002
Kellypalik Qimirpik
(1948– )
serpentine · 18 × 7 × 7½ inches

"This woman is fixing her-
self up before her husband
returns from hunting."

**Girl Braiding
Her Hair** 2003
Kiawak Ashoona,
RCA (1933– )
serpentine
20½ × 12 × 10 inches

"She is saying to the child,
'I have to be attractive. My
boyfriends will like me.'"

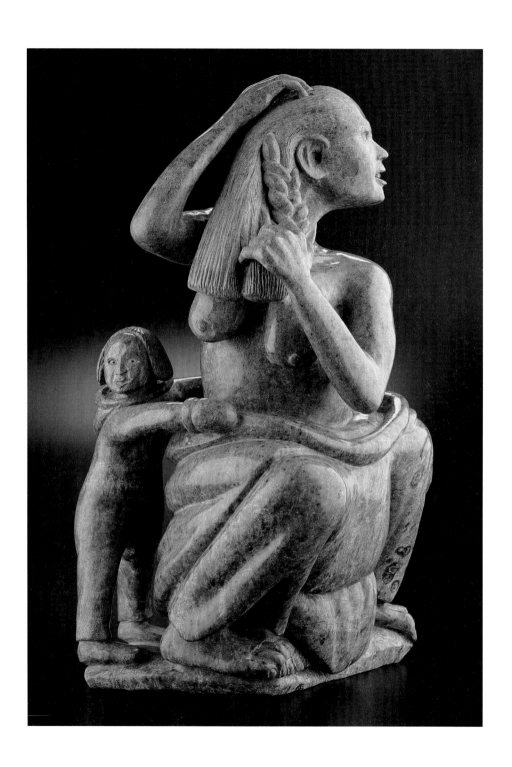

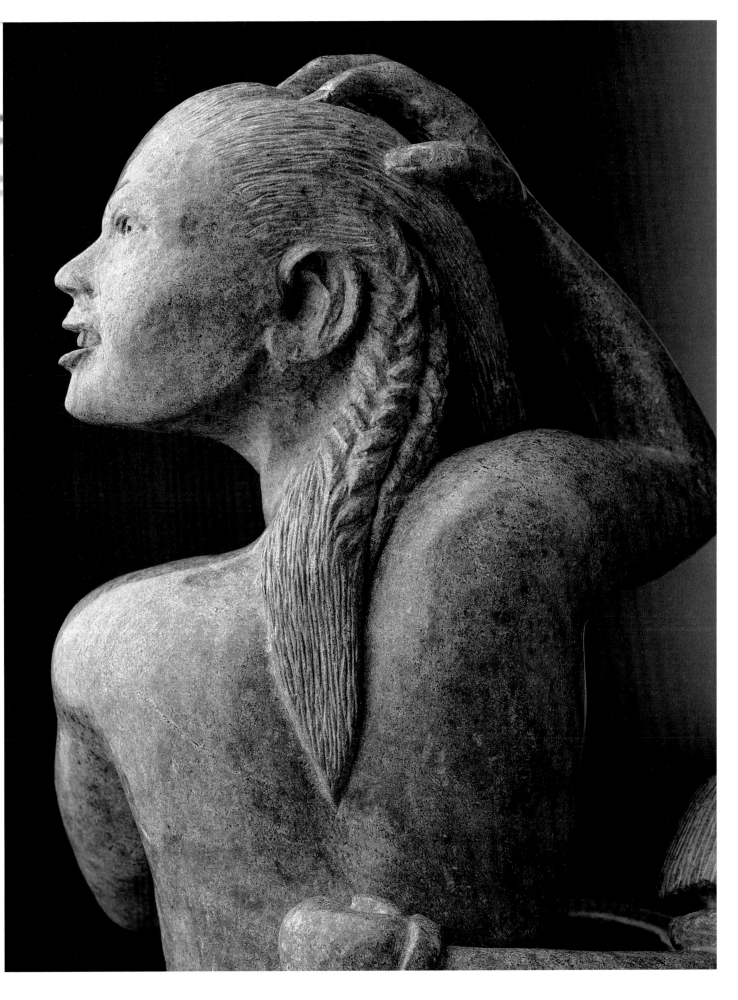

**Drum Dancer** 2003
Mayureak Ashoona (1946– )
serpentine, antler · 7½ × 6 × 9
inches (including drum)

*Facing page:*
**Girl with Braids** 2001
Pitseolak Niviaqsi (1947– )
serpentine · 15 × 12 × 6 inches

"This girl has just finished
braiding her hair and is
happy at how long her hair
has grown."

**Man on Ski-Doo** 2003
Paulassie Pootoogook,
RCA (1927– )
serpentine
8½ × 13½ × 5 inches

"This was a challenge for me.
I wanted to know if it was
possible for me to make a
carving in serpentine of a
man on a snow machine."

*Facing page:*

**Man on ATV** 2003
Napachie Sharky (1971– )
serpentine · 6 × 6 × 3½ inches

"This is not a carving of any
specific person . . . but I like
doing hard work so this

piece is one of my favourites.
I like doing different pieces
to other artists here, so I
look forward to doing some
more different carvings in
the future."

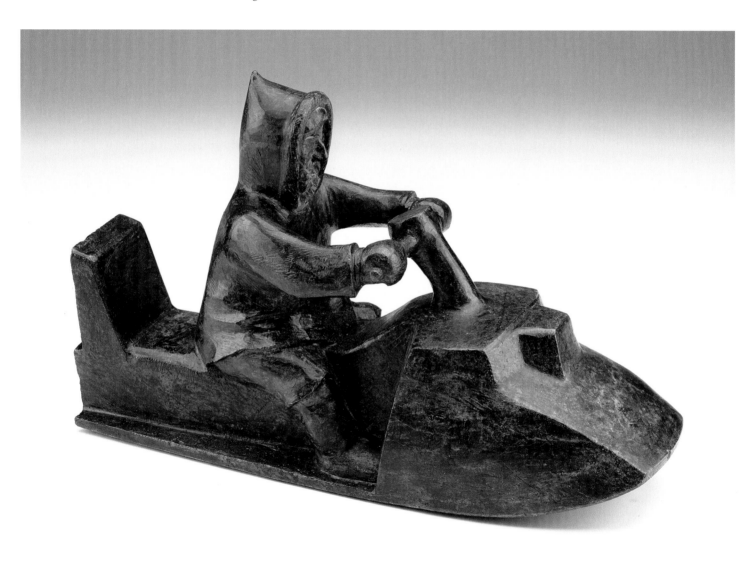

**Dying—Every time
I make one (of) these,
I die a little more** 2004
Jutai Toonoo (1959– )
serpentine · 18 × 16 × 10 inches

"When I carve, I am giving part of myself. I put so much energy and passion into the carving that I am working on that I am physically and mentally drained when the carving is finished. I do not like wearing a mask when I am carving so I also know the dust that I breathe in is killing me. Each carving that I make takes so much out of me."

## Standing by His Carvings 2004
Jutai Toonoo (1959– )
serpentine · 15 × 8 × 5 inches

"I am pleased that you like my sculptures and are including them in your book. People up here make fun of my pieces and laugh at them. I want to make my carvings like this and not do what other people are doing. I am making a statement that I believe and stand by my carvings."

*Facing page:*

## My Father Carving a Bear 2004
Oviloo Tunnillie, RCA (1949– )
serpentine, antler
14 × 12 × 9 inches

"The sculpture is of my father [Toonoo] carving a bear. I remember him carving when I was young. He liked carving bears. It was 1959, I remember I was ten years old and had just returned from hospital in the south after treatment for tuberculosis. I had been in hospital in 1955, then again from 1957 to 1959. After my third visit to hospital for six months in 1965, I sold my first carving. I only started carving seriously when I had my first child in 1970."

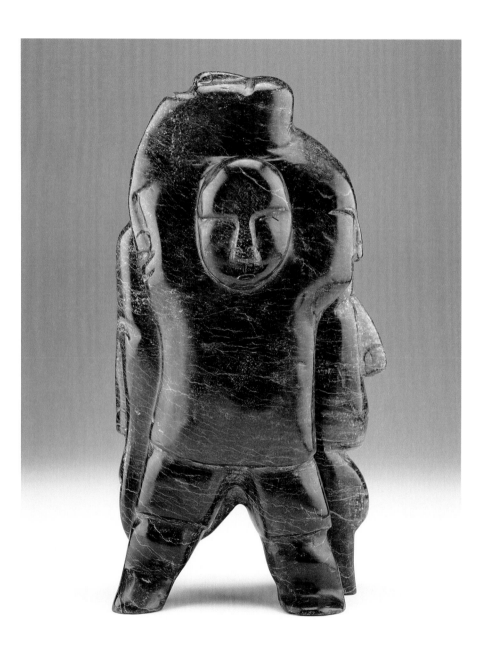

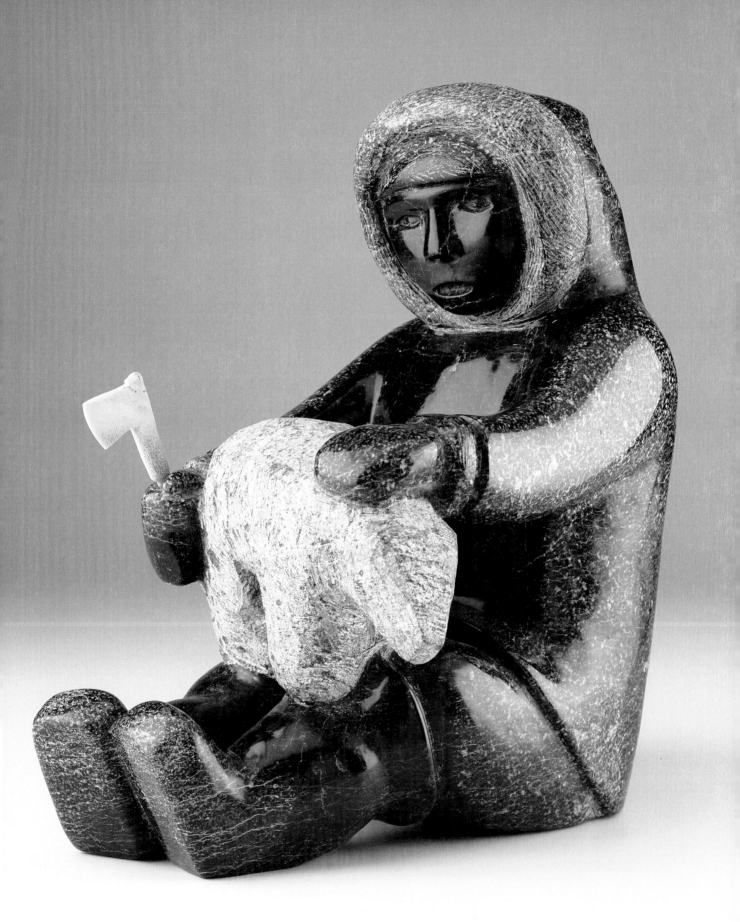

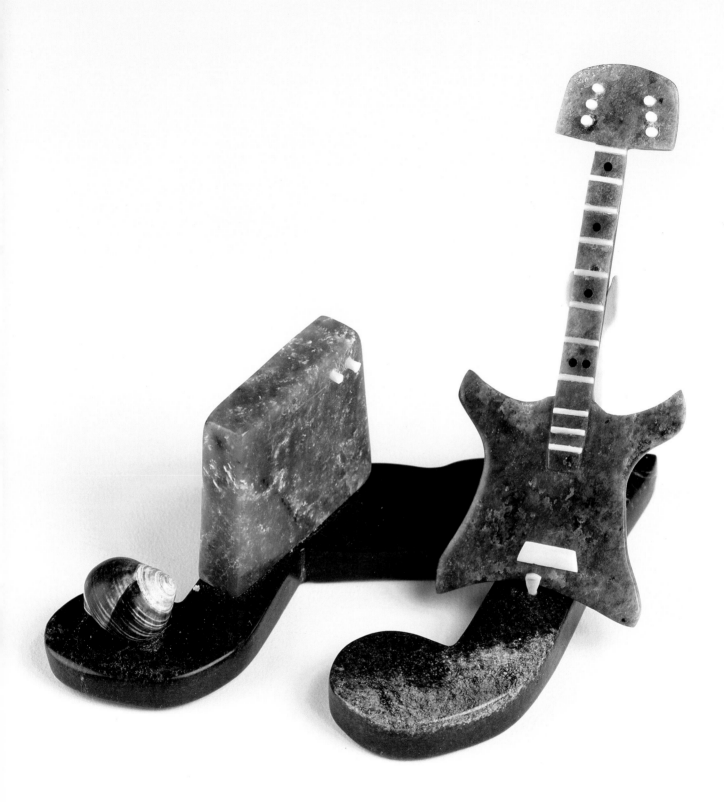

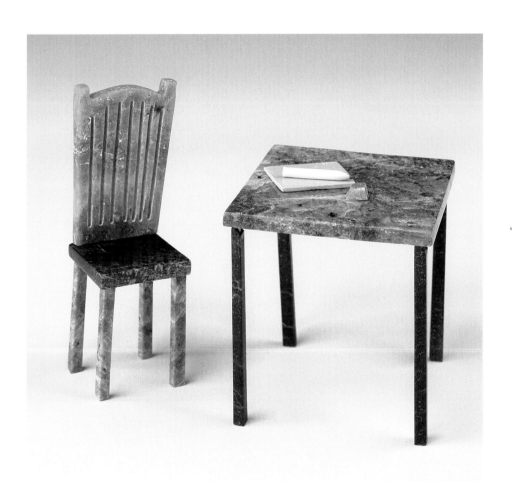

*Facing page:*

**On a Musical Note** 2004
Jamasee Padluq
Pitseolak (1968– )
serpentine, shell, ivory inlay
3¼ × 4½ × 4 inches

"I do not play the guitar but have always wanted to. I like listening to music, especially the Beatles and old stuff from the 1960s. The shape of the guitar reminds me of a beautiful woman singing nice tunes. I put the shell in as I like adding different things to my carvings. The shell came from my mother, Oopik Pitseolak, who found it somewhere."

**The Student** 2004
Jamasee Padluq
Pitseolak (1968– )
serpentine, calcite,
limestone, ivory, baleen
chair 3¾ × 1 × 1½ inches
table 2½ × 3 × 2¾ inches

"I enjoy carving small pieces and having fun. I made the chair—but thought, it cannot stand by itself. So then I added the table. It reminded me of a desk, so I put a pencil, paper and an eraser on it. The eraser is made from an orange calcite, the pencil is ivory with baleen on the end and the paper, I think, is limestone."

**Cribbage Board
with Polar Bear** 2004
Emataluk Saggiak (1955– )
ivory · 1¾ × 17 × 2 inches

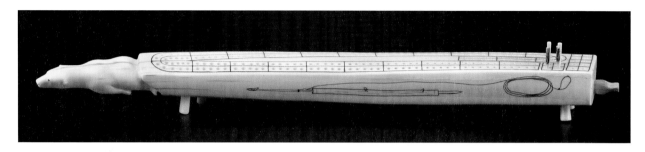

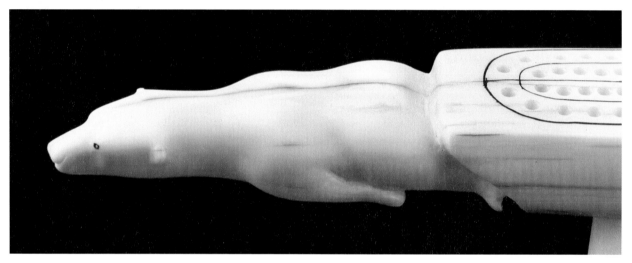

*Facing page:*

**Arctic Christ** 2002
Johnnysa Mathewsie
(1984– )
serpentine, marble, wood
9½ × 7 × 5 inches

"I am not really a Christian and do not go to church, although my mother and father do. I wanted to carve something different, and I had not seen someone do this before. It is an Inuk crucifixion, but I am not making a political or religious statement. I wanted to have Christ in Inuk clothing. It was my first religious piece, and I am very proud of it. I have carved an angel since. I like mixing stones in my carvings and used a piece of the white stone. I put INDI [*sic*] on the top of the cross because people told me that was always on there. The sculpture means more to me since I saw the movie *The Passion of the Christ*."

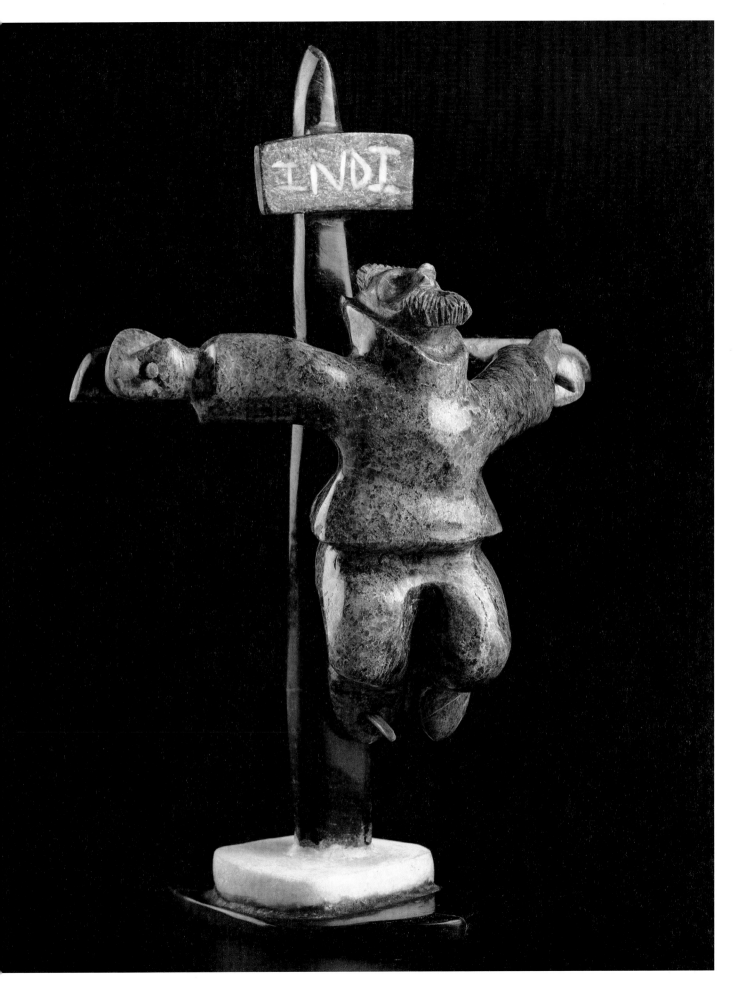

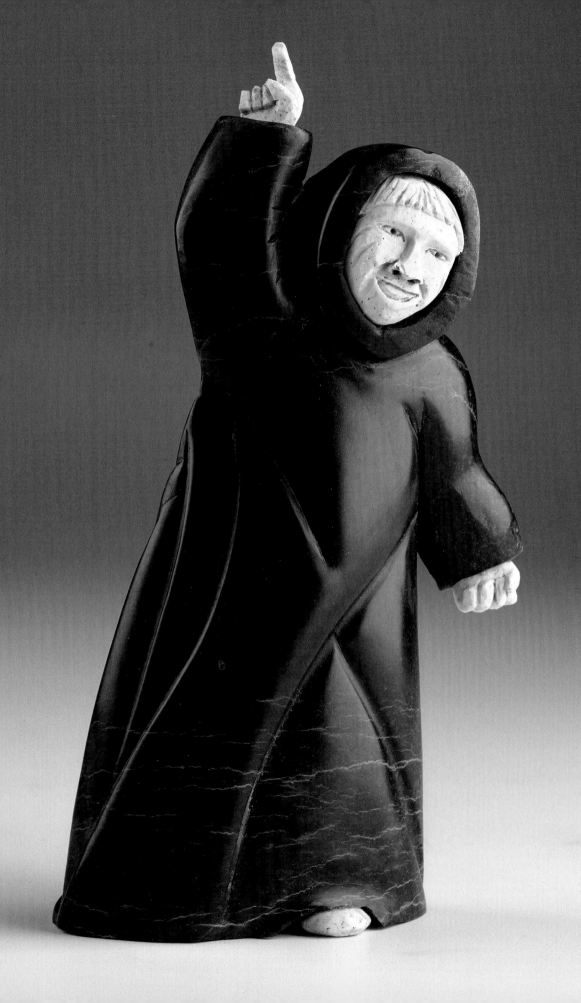

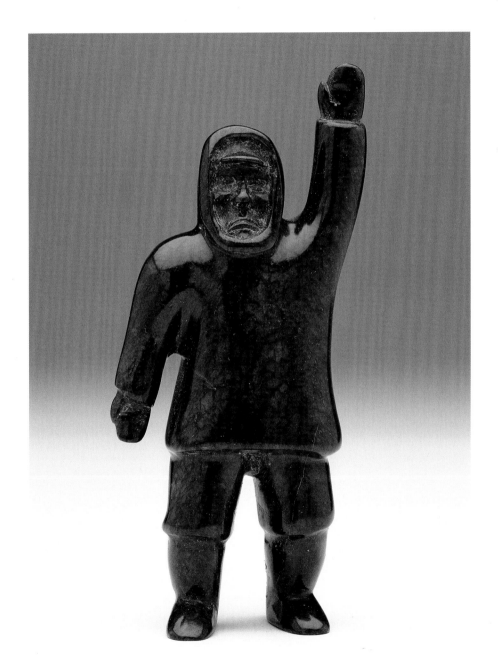

**Preacher** 2002
Samonie Toonoo (1972– )
serpentine, bone inlay
7½ × 4 × 2 inches

"This is a carving of a
preacher. As you can see,
he is pointing up to the sky
and is wearing some kind of
robe that they like to wear."

**Waving Hunter** 2002
Qaunaq Mikkigak (1932– )
serpentine · 6½ × 3 × 1½ inches

"This carving is of a person
waving. Waving is called
*nuloagartuq*, waving at
people who are leaving on
a long journey."

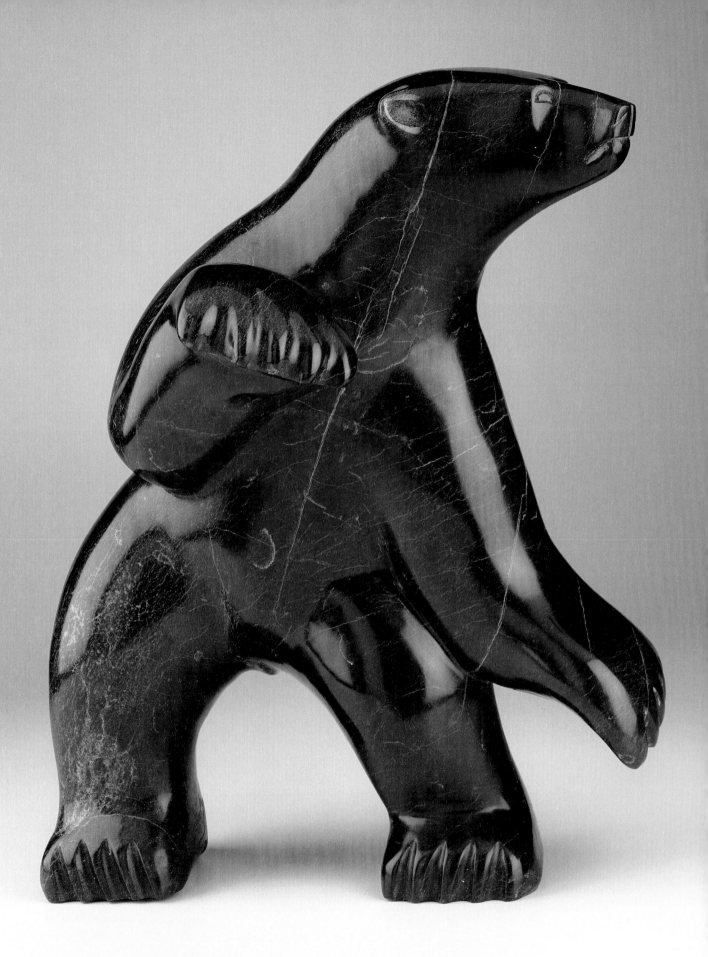

# OUTSIDE THE IGLOO

## ARCTIC WILDLIFE

## AND LIFE ON

## THE LAND

**God Gives Us Arctic
Animals** 2001
Mathew Saviadjuk
(1950– )
serpentine, ivory
10 × 17 × 11 inches

"I have little to say about
this piece except god is
the creator and created all
animals. There is no story
to it . . . I just love carving.
I started carving the wal-
rus and it just happened to
come out this way with
other birds and animals."

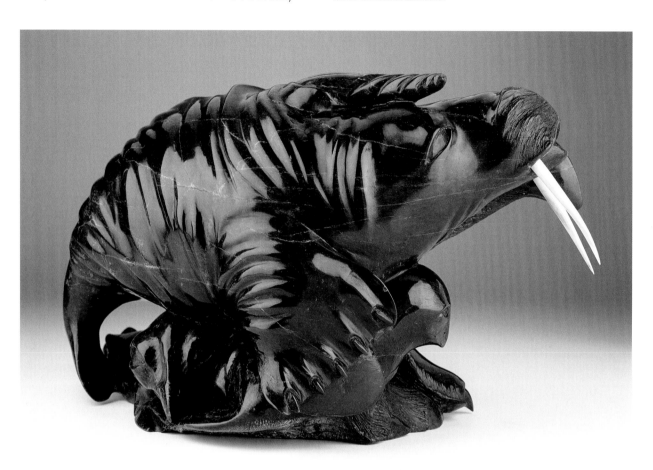

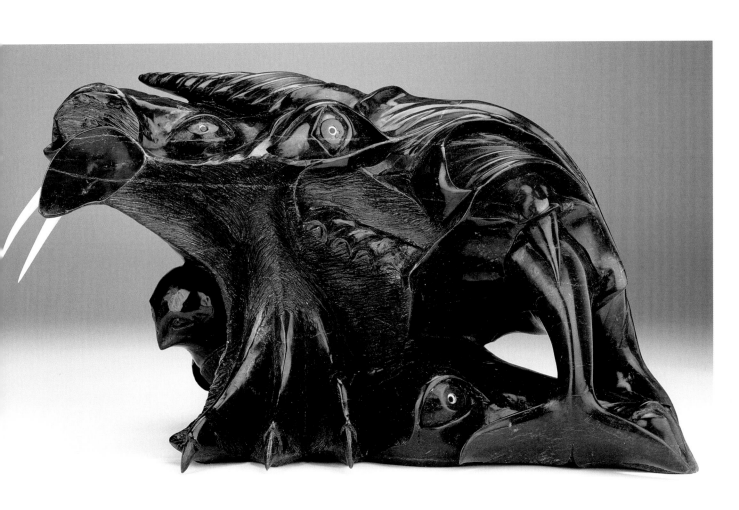

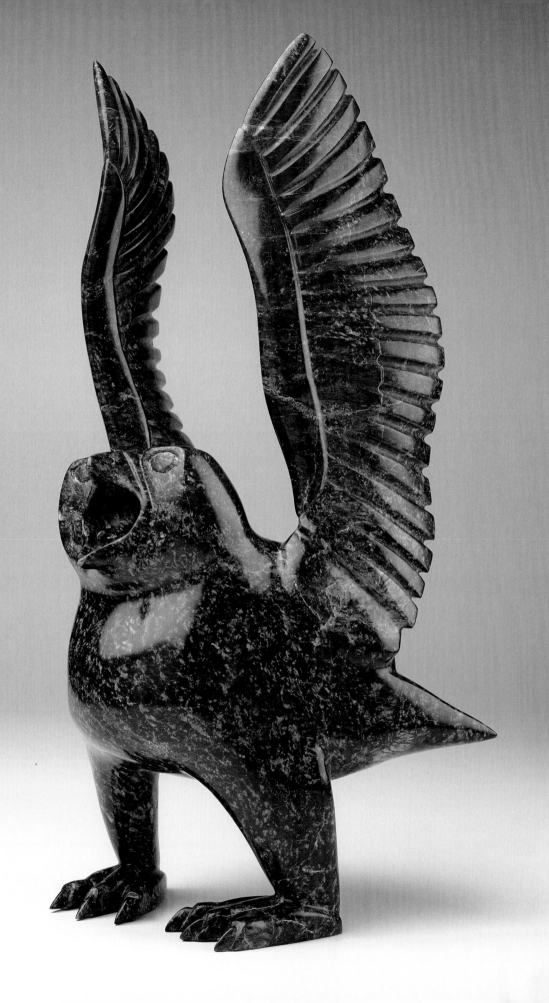

**Stalking Young
Falcon** 2002
Markoosie Papigatok
(1976– )
serpentine · 9 × 15 × 7½ inches

**Attentive Young
Falcon** 2002
Markoosie Papigatok
(1976– )
serpentine
8½ × 14 × 7½ inches

"These are falcon chicks!"

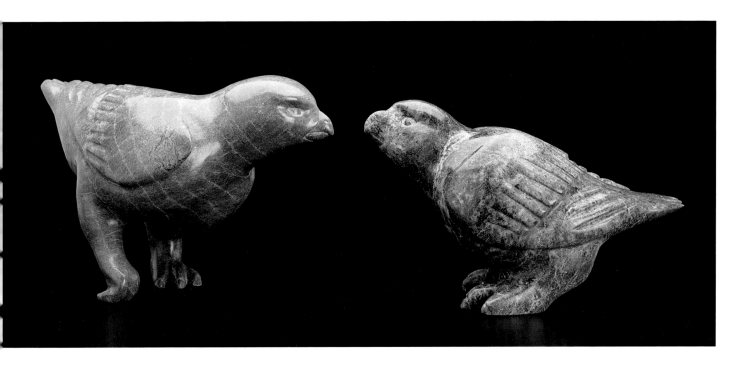

*Facing page:*

**Young Owl** 2004
Pootoogook Qiatsuk
(1959– )
serpentine · 19 × 9 × 9 inches

"I like carving owls. I have
seen owls done by my
grandfather, Kiakshuk, in
books. I do not remember
him, as I was too young. I
have also watched as my
father, Lukta, carved owls. It
is good that owls continue to
be carved through the gen-
erations in our family. This
owl is a young owl. The owl
is screeching for food, as it
is hungry. It is standing at
the nest stretching its wings.
The wings are still weak,
so the owl cannot fly. The
owl is waiting for food from
the mother owl. Owls are a
favourite subject for me in
my carvings and jewellery."

**Guardian Owl** 1997
Kenojuak Ashevak,
RCA (1927– )
etching and aquatint on paper
(edition of 100)
31½ × 39 inches

*Facing page:*

**Gathering Kelp** 1986
Kananginak Pootoogook,
RCA (1935– )
woodblock print on paper
(edition of 50) · 23 × 16 inches

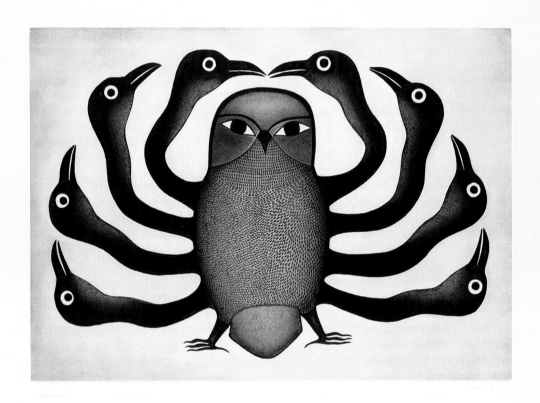

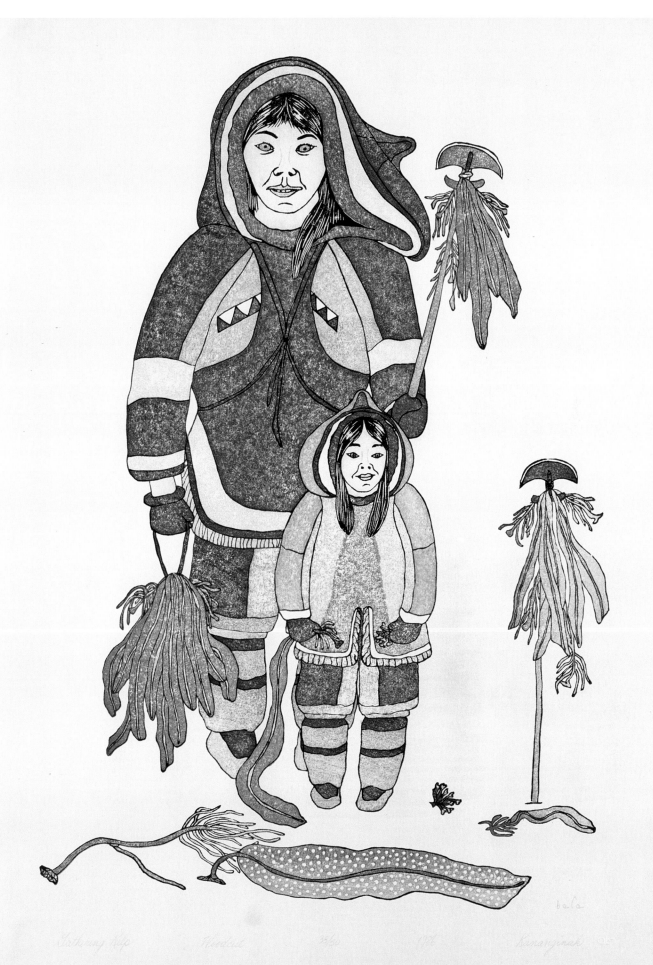

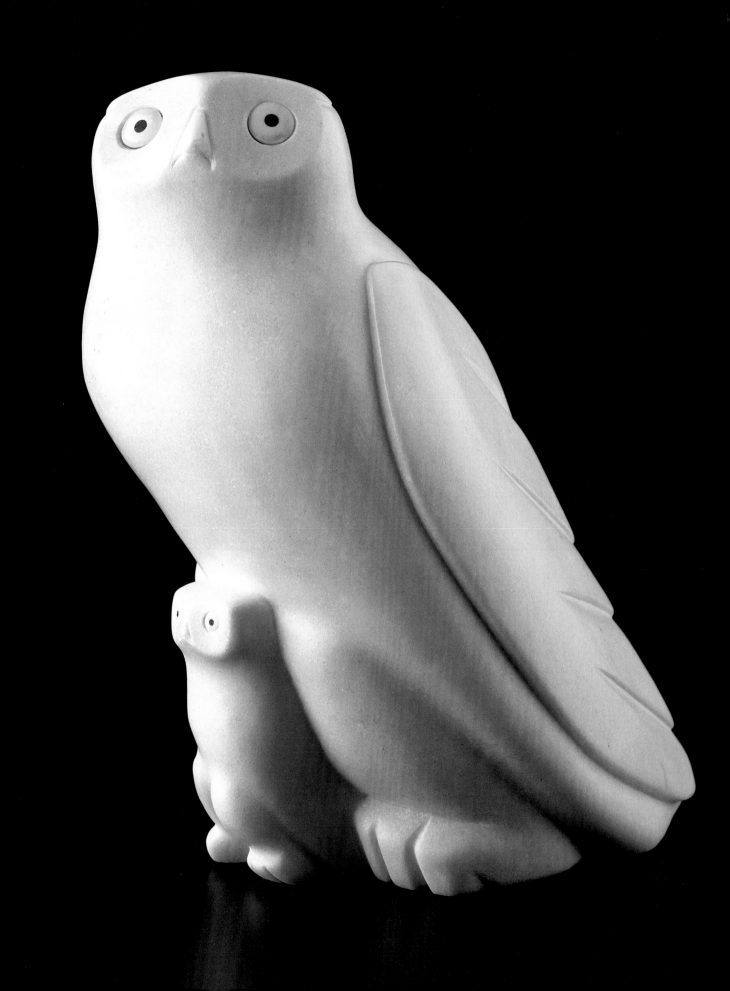

*Facing page:*

**Owl with Young** 2003
Joanassie Manning (1967– )
marble, antler, serpentine inlay
12½ × 10 × 7 inches

"Owl protecting chick from
predators."

**Owl Defending Nest** 2000
Lukta Qiatsuk (1928–2004)
serpentine · 10 × 8 × 12 inches

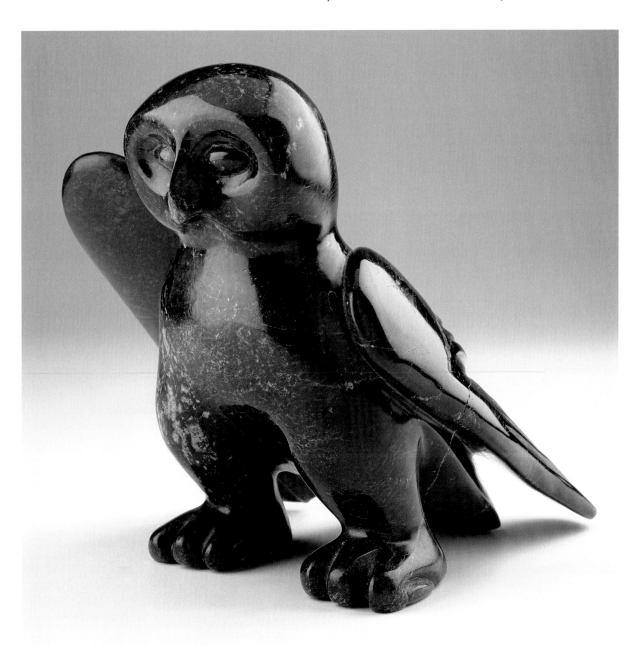

**Woman Enjoys Fishing** 2004
Adamie Ashevak (1959– )
serpentine, wood, antler,
whalebone, ivory, sinew
28½ × 16 × 10 inches

"During the springtime, it is
common for a family to go
out fishing on the ice. While
the woman is jigging for fish,
it is usual to carry the baby
in the hood of the *amauti*.
Carrying a baby here does
not stop a woman from
jigging and doing other
tasks on the land. Women
really enjoy fishing in the
North. It is a favourite time
for the family. This is the
first time that I have carved
a figurative piece in a long
time and the biggest sculp-
ture that I have ever carved."

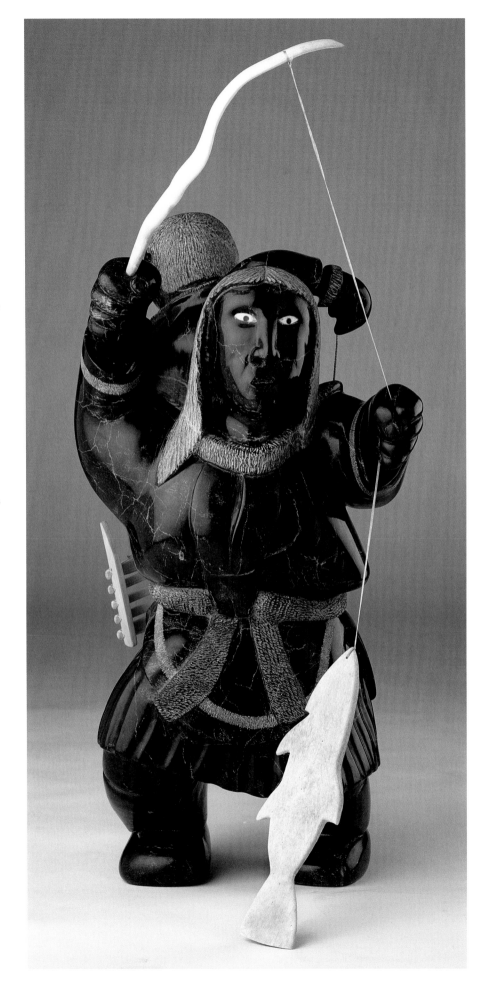

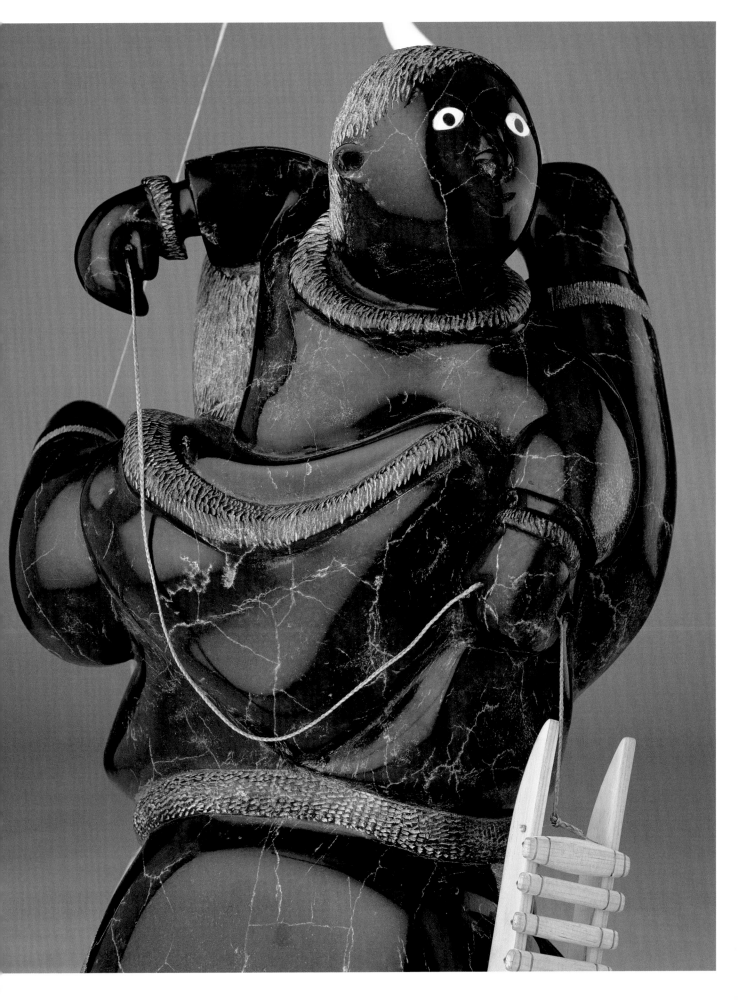

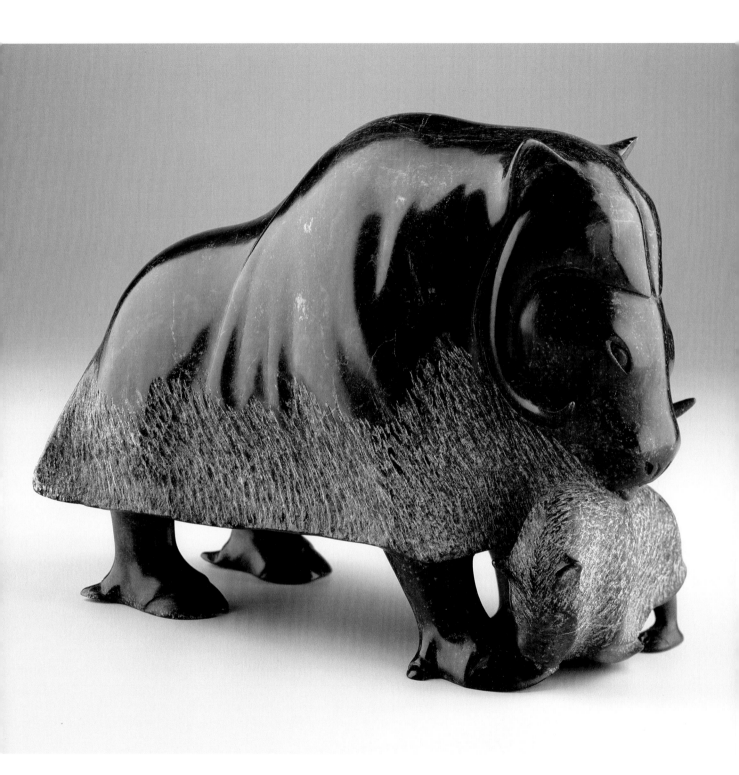

CAPE DORSET SCULPTURE

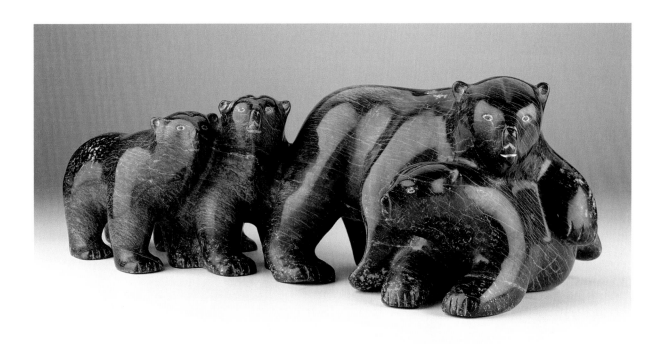

*Facing page:*

**Muskox Protecting
Calf** 2003
Mathew Saviadjuk
(1950– )
serpentine · 9 × 11½ × 5 inches

"I like this beautiful animal
and like to carve it. They are
not easy to carve. I have
carved muskox for many

years but had only seen
them on TV, as there are no
muskox in Cape Dorset. The
first time I saw real muskox
was when I was in Cam-
bridge Bay for the Nunavut
Art Festival in 2001."

**Hunter with**

**Harpoon** 2003
Pudlalik Shaa (1965– )
serpentine, antler, sinew
18 × 11½ × 8 inches

"This carving is of a hunter
and a composition of birds
and animals. The carving
has a falcon, goose and a
walrus on a polar bear's paw
base. All are hunters in the
Arctic. I have no idea what
I am going to do when I
start a carving, but I just let
my imagination take over.
I like carving pieces like
this that many images.
When I was carving this,
I kept on thinking about the
hunter and the speed of the
harpoon."

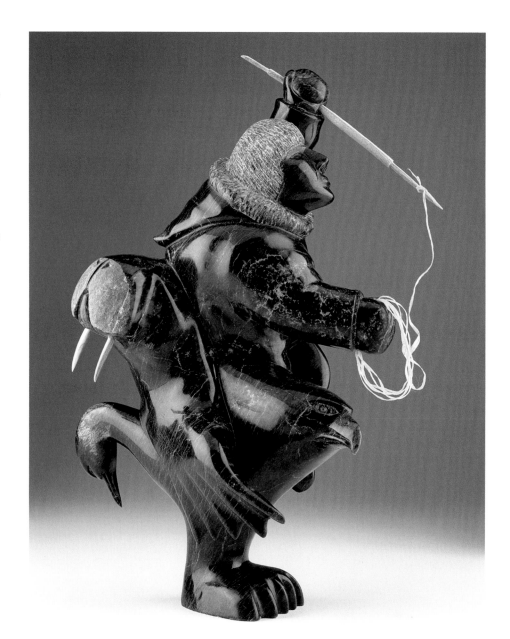

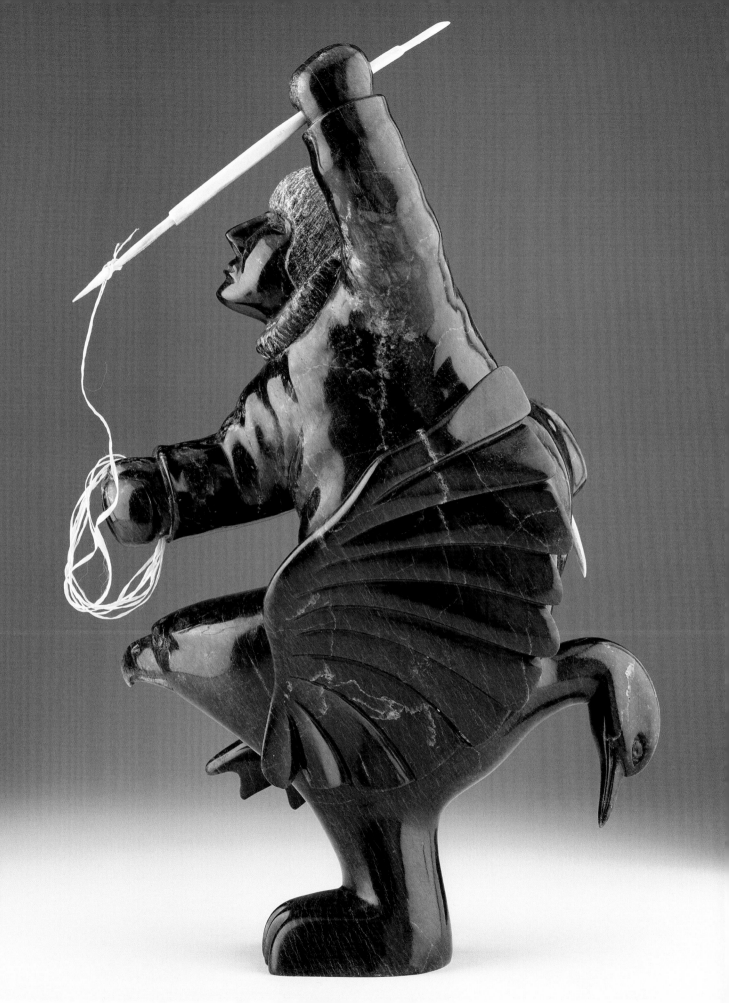

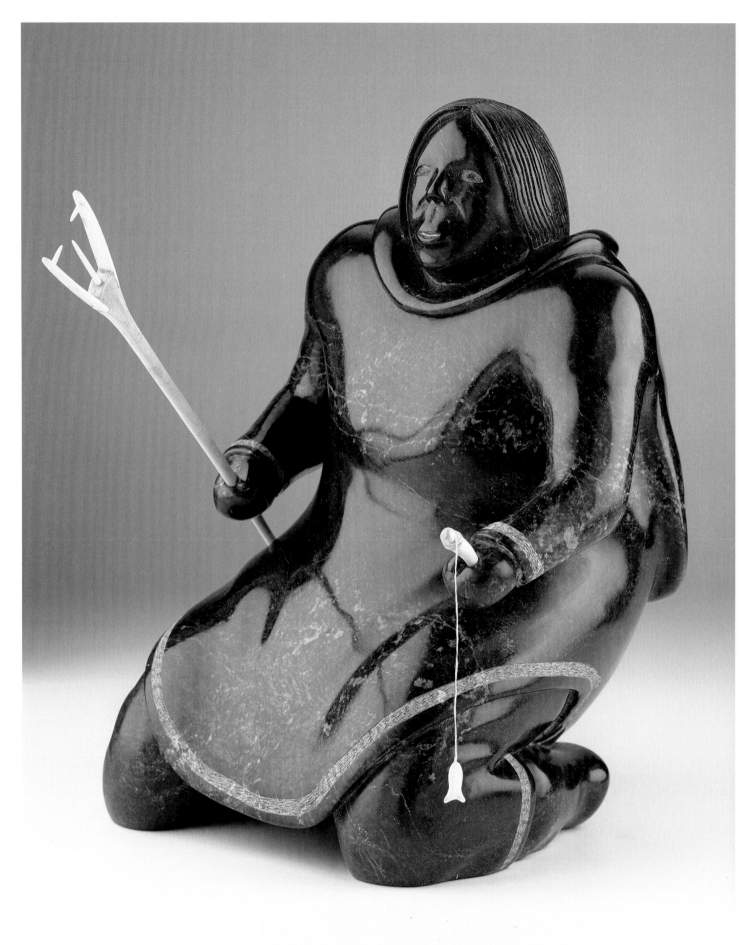

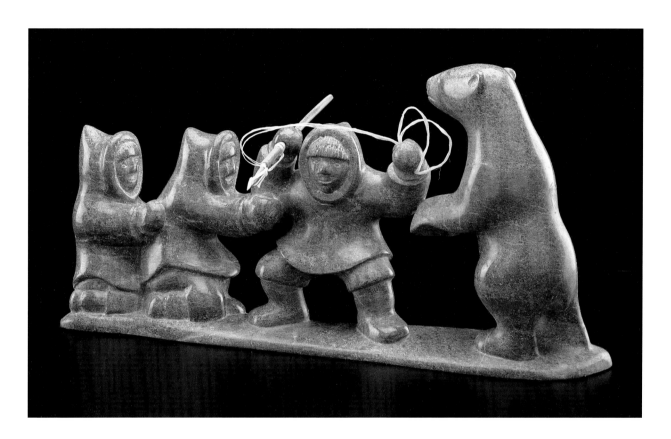

*Facing page:*

**Kneeling Woman
Jigging for Fish** 2001
Joanassie Manning
(1967– )
serpentine, antler, wood, sinew
15 × 10 × 11 inches
(excluding trident)

"Woman fishing in winter
for survival."

**Hunters and a Bear** 2001
Taqialuk Nuna (1958– )
serpentine, antler, sinew
7 × 15 × 3 inches
(excluding harpoon)

"My father [Sharky Nuna] is
on the land hunting a polar
bear with my older brother
[Qavavau Nuna] and me."

**Eagle with Wings
Outstretched** 2004
Napachie Sharky (1971– )
serpentine · 13 × 20 × 4½ inches

"This bald eagle is calling for
its mate and is ready to have
fun. I really enjoyed working
on this sculpture big time."

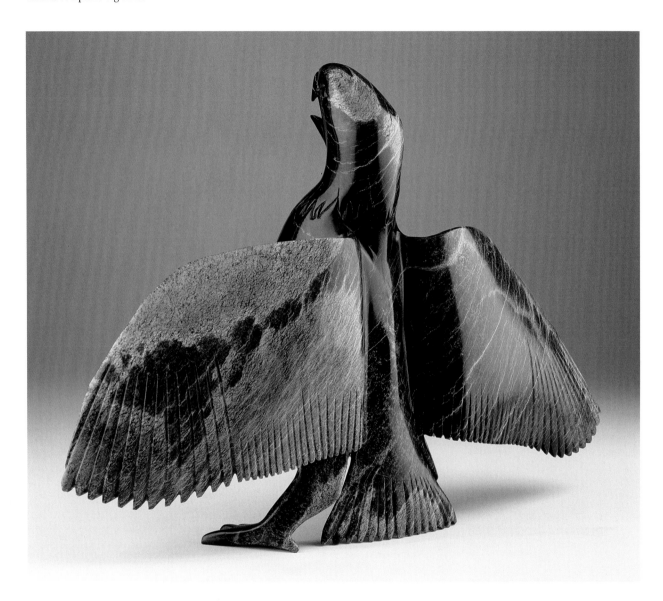

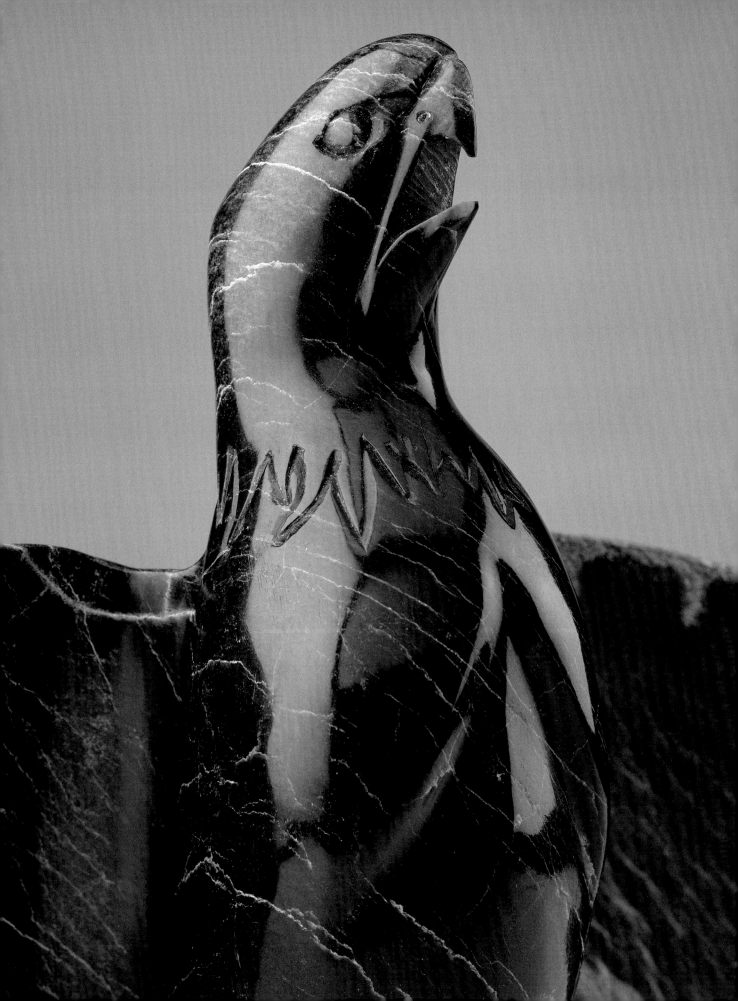

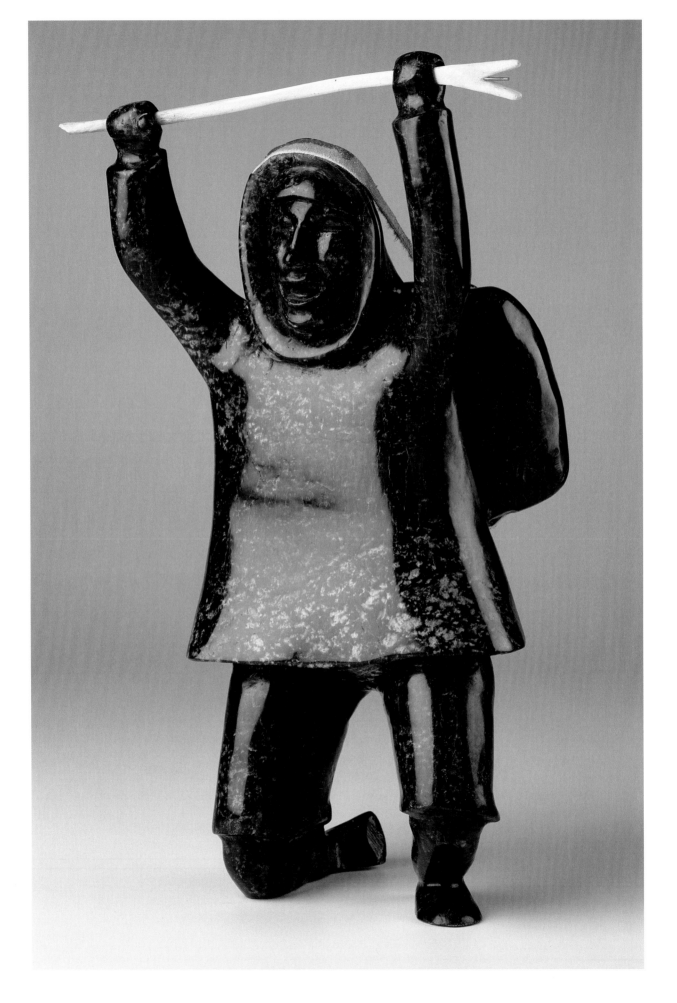

**Startled Bird** 2001
Napachie Sharky (1971– )
serpentine · 3 × 8¼ × 5¼ inches

"I call this bird a snow
bunting. It is not easy to
carve, and takes a lot
of time and hard work.
I enjoy carving birds."

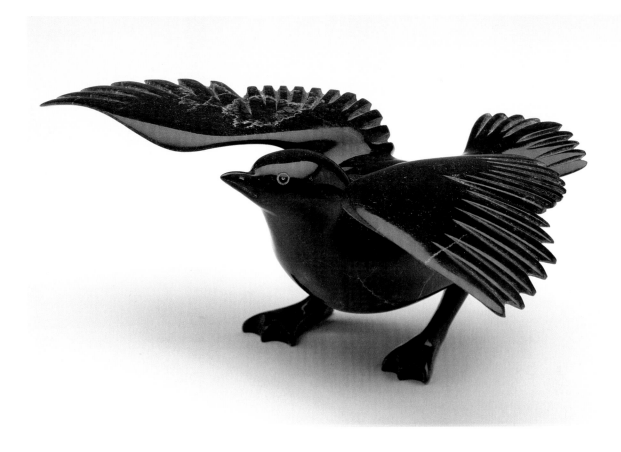

*Facing page:*

**Hunter Packing
Heavy Load** 2002
Paulassie Pootoogook,
RCA (1927– )
serpentine, antler, caribou hide
16 × 9 × 7 inches

"The man has a heavy pack
of caribou meat. He is hold-
ing a *qakivak* [fish spear]
in case he runs into a
fishing area."

**Snowy Owl** 2001
Pootoogook Jaw (1959– )
white marble, black marble
9¼ × 9½ × 5 inches

"I made this marble carving
of the snowy owl because
first of all the stone is
white and spotted like the
colouring on their feath-
ers. Therefore, I carved in
more deep cuts and grooves
to show more of the details
of the feathers on the back.
I added the black marble
stone eyes and beak. I was
experimenting with this
work and wanted to see
if it would be liked. It is
made from a local marble
just two miles away from
Cape Dorset."

*Facing page:*

**Owl with Lemming** 2002
Paulassie Pootoogook,
RCA (1927– )
serpentine
13 × 7 × 7 inches

"I have seen a snowy owl
with a lemming, and lem-
mings are a main source
of food for owls."

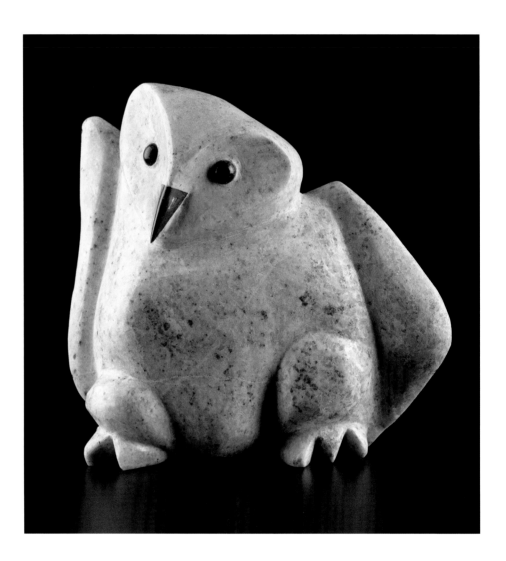

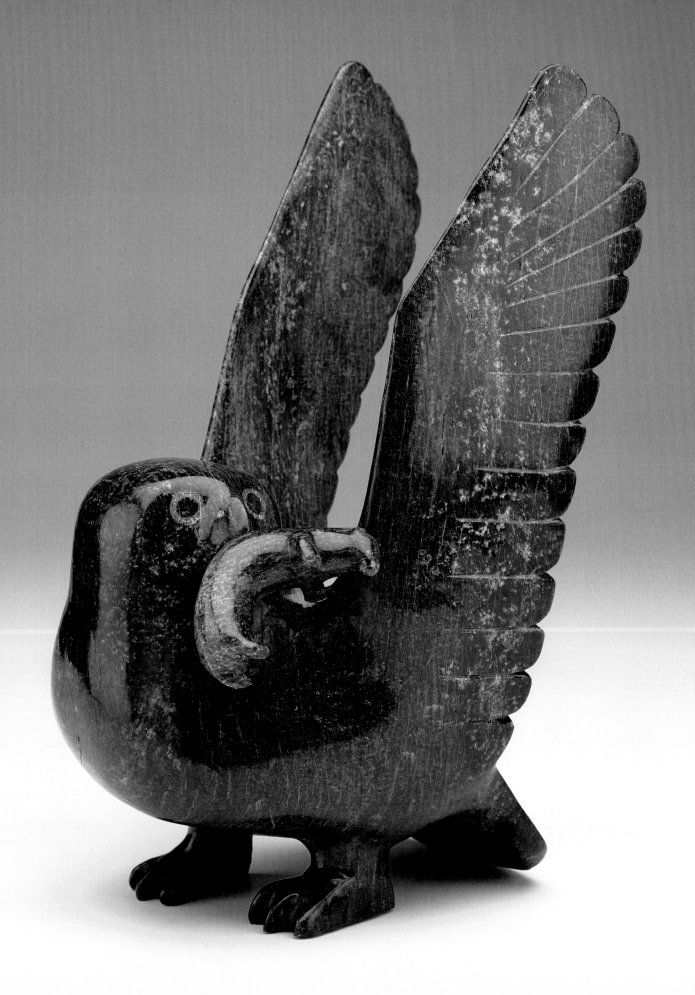

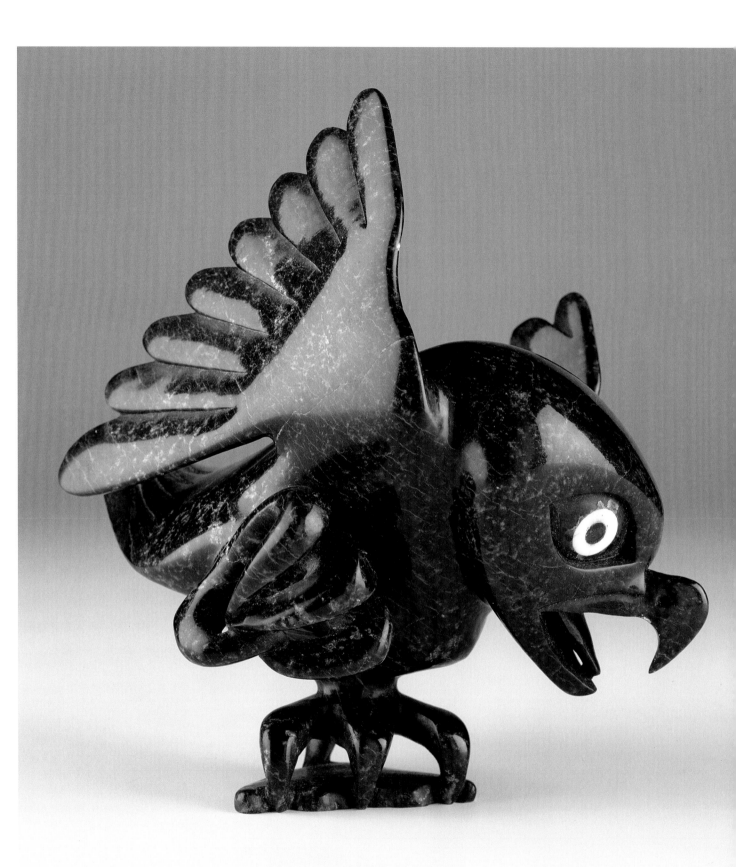

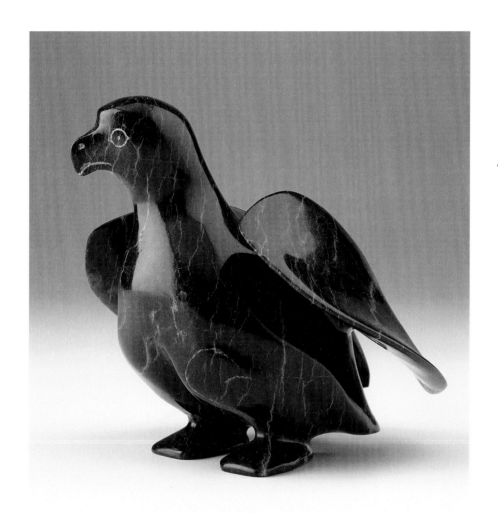

*Facing page:*

**Dancing Bird** 2003
Toonoo Sharky, RCA
(1970– )
serpentine, ivory inlay
9 × 8 × 6½ inches

"Not for being an idle one, he likes to balance on one foot without falling. After balancing, he started dancing and enjoying the feeling of being a dancer. [He] did not know he was being a bird!"

**Arctic Bird** 2003
Suqualuk Akesuk (1959– )
serpentine · 7 × 7 × 7 inches

"This is my interpretation of an Arctic bird in my own style. It is not a specific type of bird, but one out of my imagination."

**Loon** 2004
Mikisiti Saila (1939– )
serpentine · 5 × 16 × 5½ inches

*Facing page:*

**Basking Seal** 2001
Ashevak Tunnillie (1956– )
serpentine · 7½ × 8 × 4½ inches

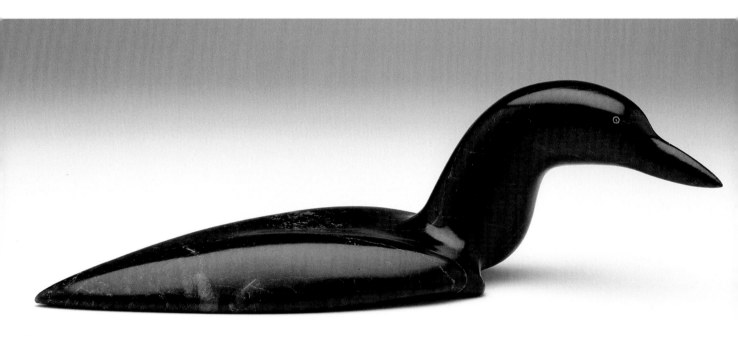

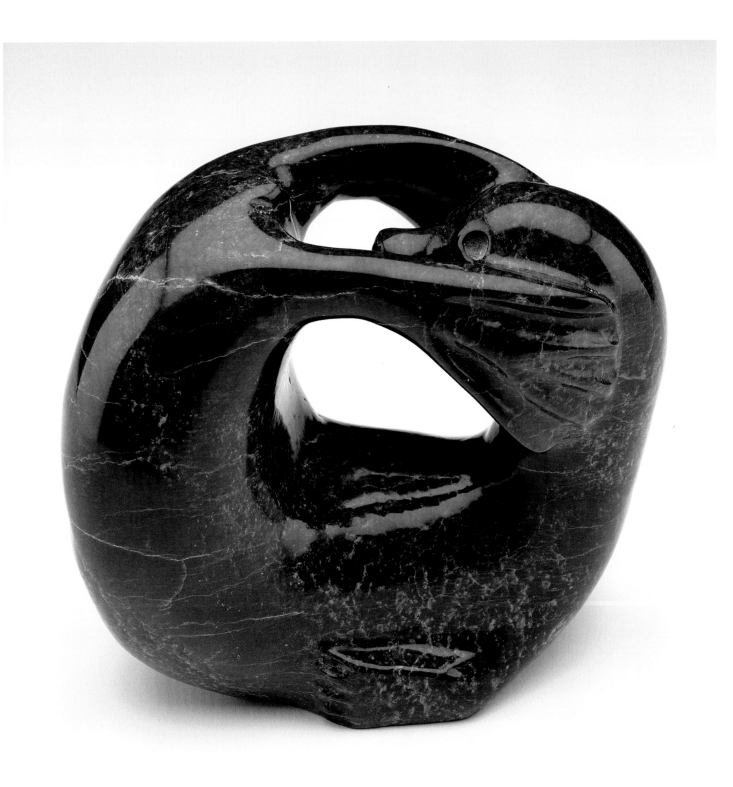

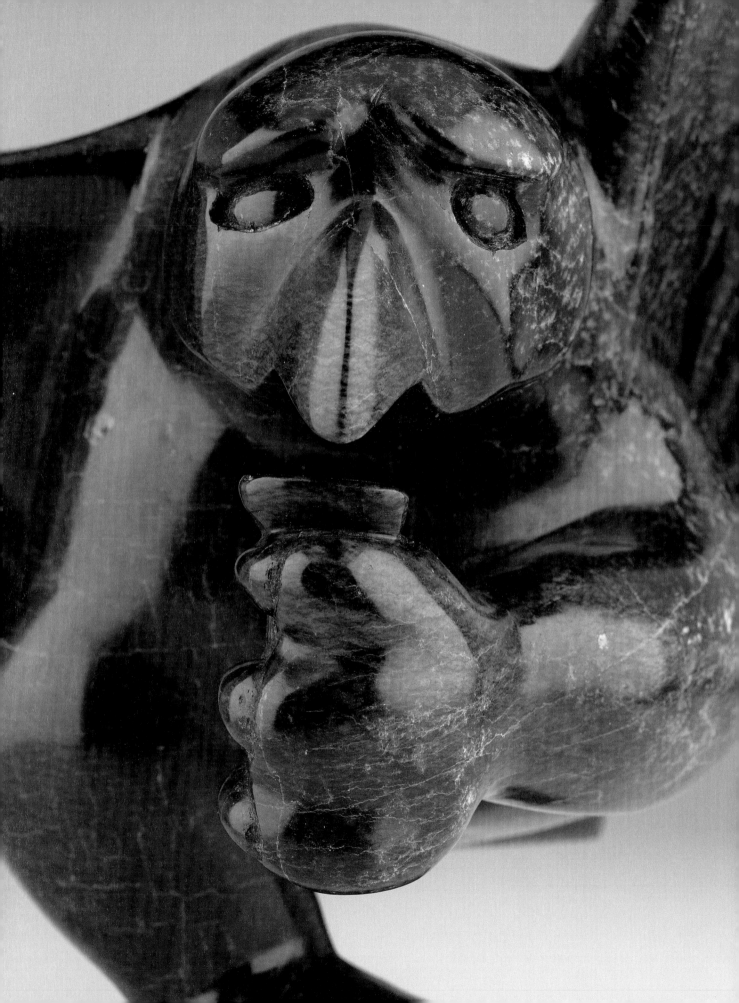

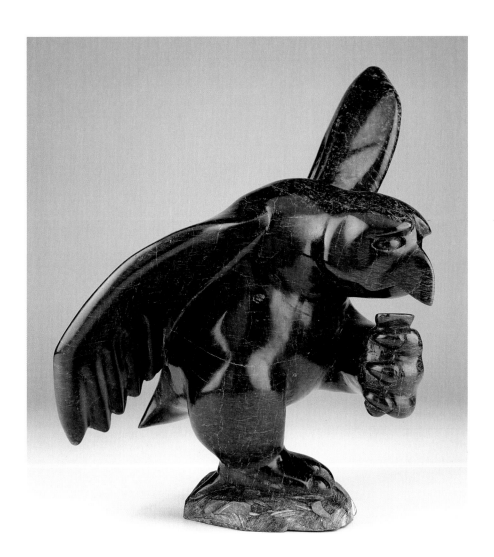

**Dancing Owl** 2003
Aqjangajuk Shaa,
RCA (1937– )
serpentine
15¾ × 14 × 13 inches

"Snowy owl dancing in the
snow with food."

**Mating Polar Bears** 2001
Ashevak Tunnillie (1956– )
serpentine · 10 × 13 × 4 inches

*Facing page:*

**Combination Bears** 2003
Etidloi Adla (1982– )
serpentine · 9 × 4 × 3 inches

"I have always carved bears but wanted to do something different. There are many people carving bears, so I wanted to do something new that would catch the eye of a collector. I started with a dancing bear but wanted to make it with a different base; I began with the idea of it being a mask, but this one became a prowling bear. I have never seen this done before. I have been carving a series of sculptures using different combinations of bears so that is why I call it this. I do carve often, but I am also very busy as chairman of the local youth committee and I also coach minor hockey too."

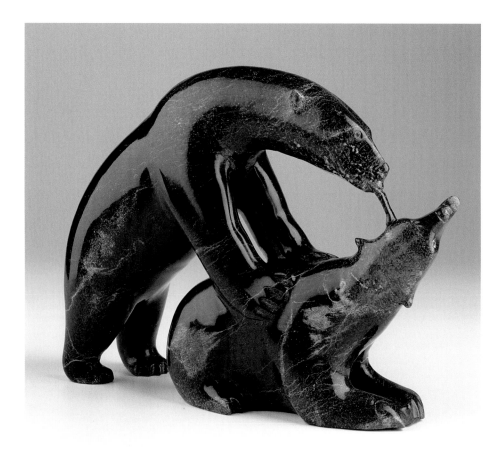

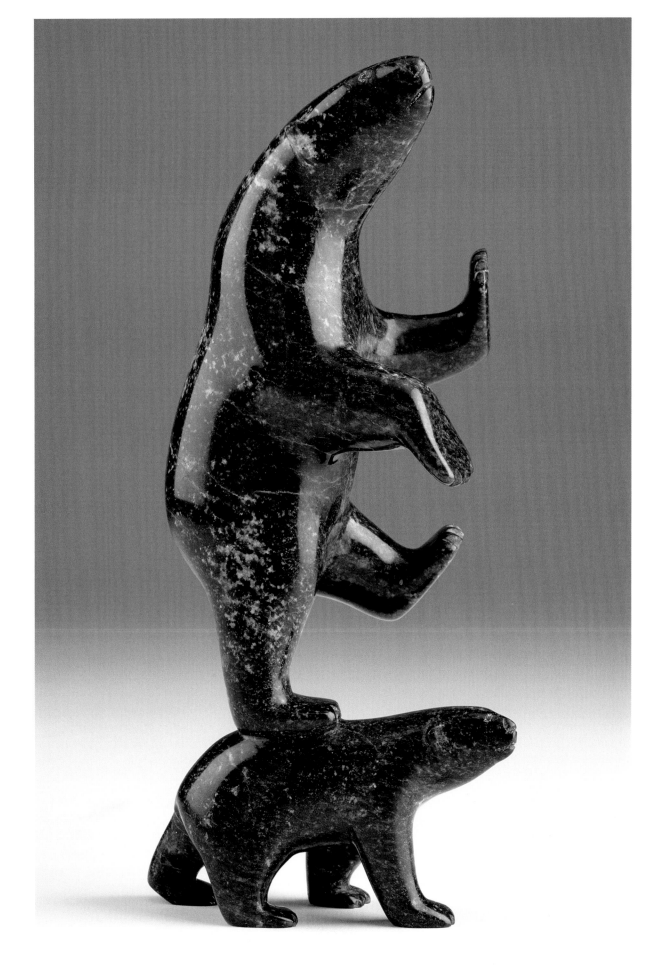

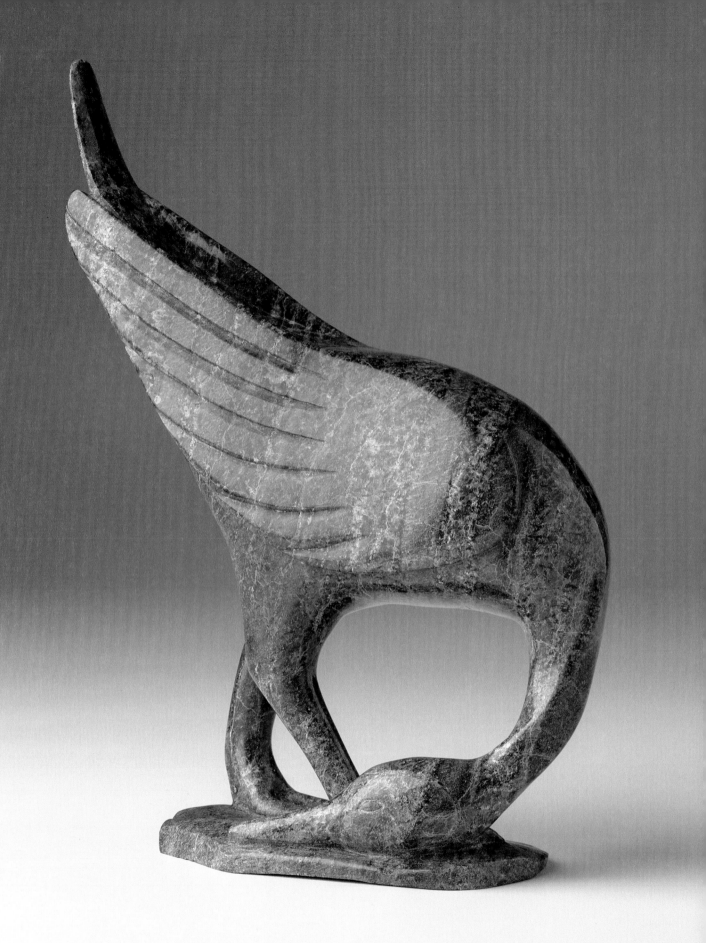

*Facing page:*

**Bird Preening** 2003
Pitseolak Niviaqsi (1947– )
serpentine · 9 × 7 × 2½ inches

"This bird is cleaning itself
on the water. Birds clean
their feathers regularly."

**Windswept Muskox** 2003
Kananginak Pootoogook,
RCA (1935– )
serpentine · 10 × 12 × 10 inches

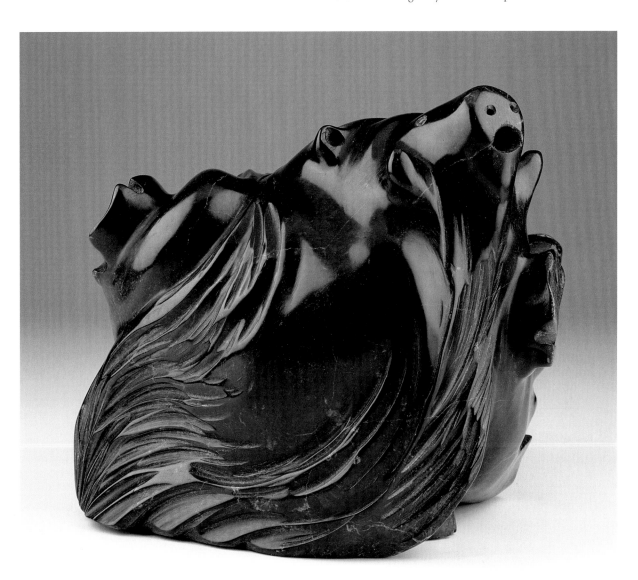

**Scenting Bear** 2002
Ohito Ashoona (1952– )
serpentine
6½ × 7 × 3½ inches

"This scenting bear is
smelling a seal that is
very distant."

*Facing page:*

**Jubilant Bear** 2003
Nuna Parr (1949– )
serpentine
22 × 18 × 14 inches

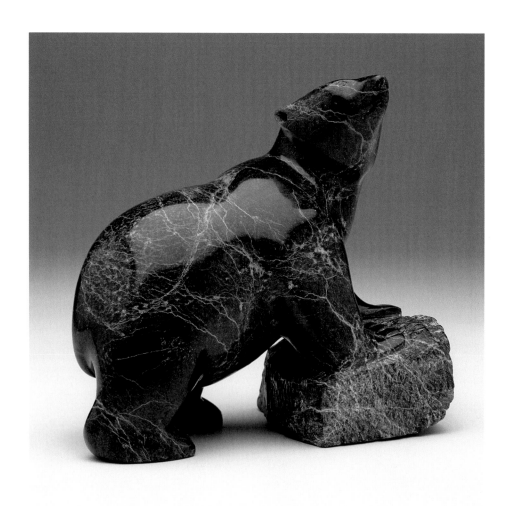

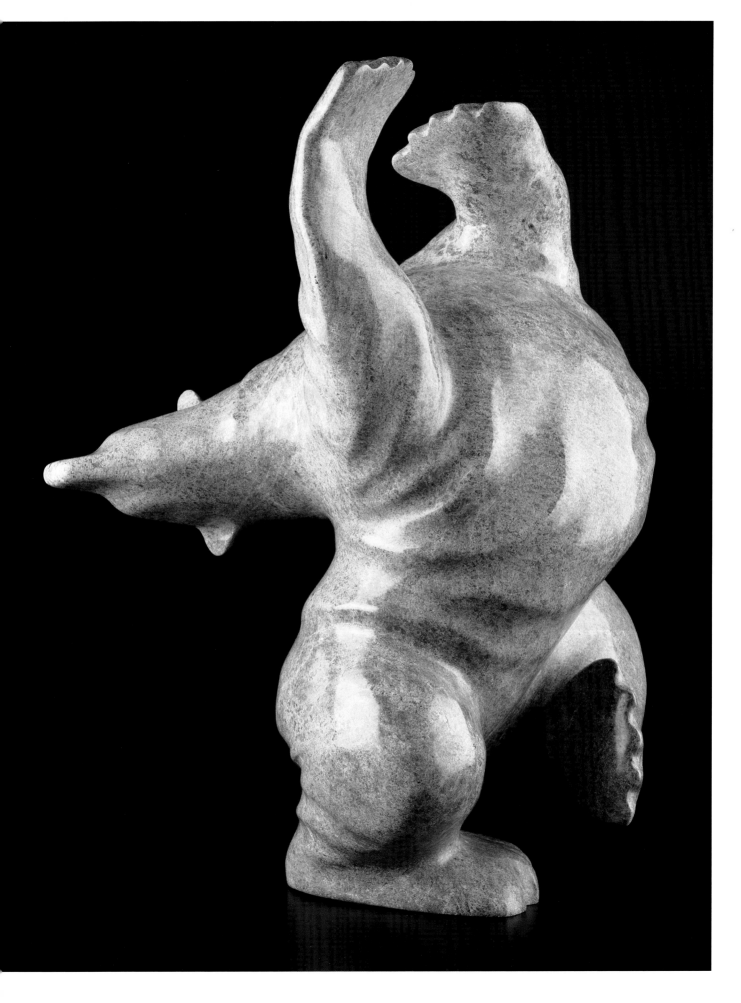

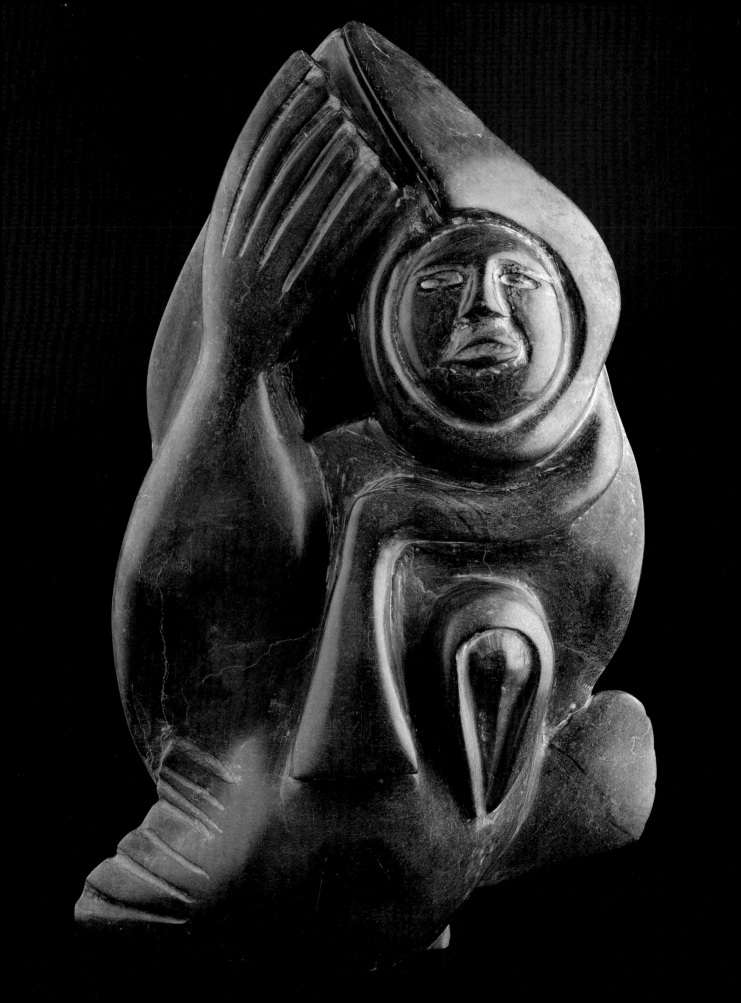

**Inuit, Owl
and Walrus** 2002
Mayureak Ashoona
(1946– )
serpentine
24½ × 15½ × 5 inches

"Inuit were very happy when
they caught walrus. Owls
used to be hunted in the
past. Walrus are very good
when cooked and give
strength to the body."

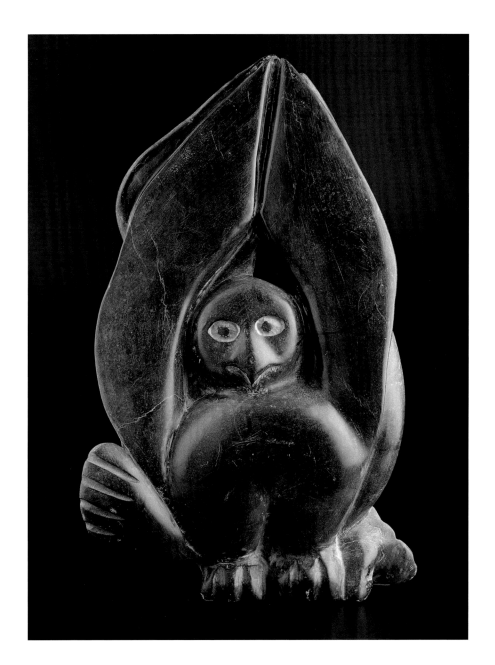

## Seal Hunting at Night

2000–01
Kananginak Pootoogook,
RCA (1935– )
ink and crayon on paper
26 × 20 inches

Translation of Inuktitut syllabics: "The men were determined and worked hard, and today we don't go through hardships."

*Facing page:*

## Char and Shellfish

2002–03
Kenojuak Ashevak,
RCA (1927– )
ink and crayon on paper
20 × 26 inches

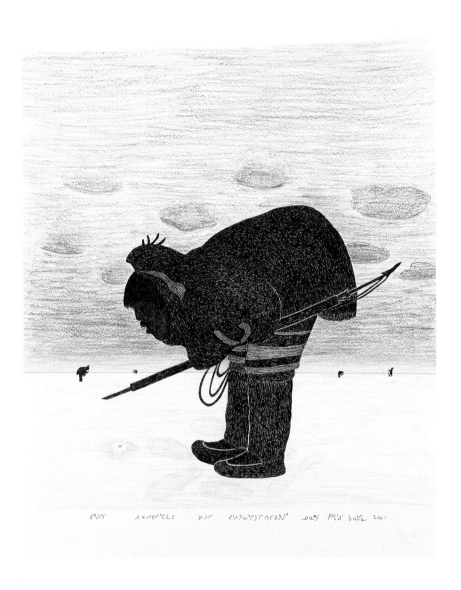

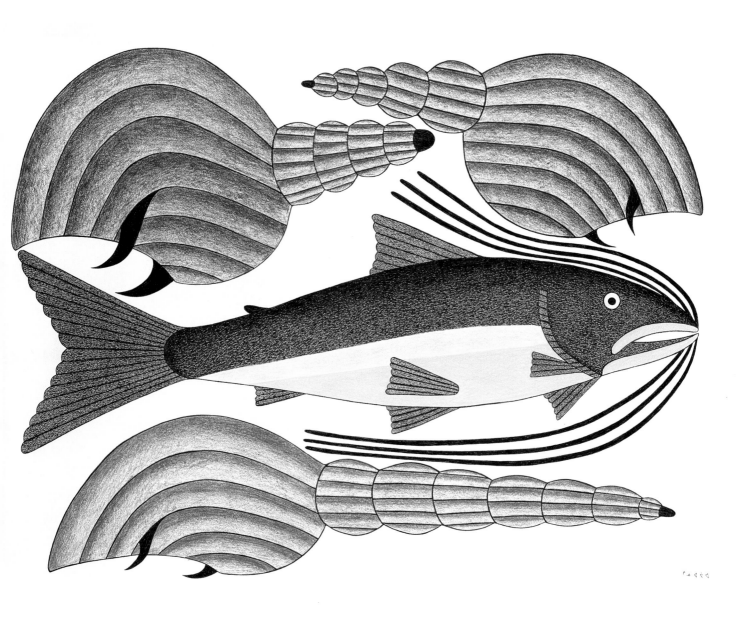

**Dancing Walrus
with Clam** 2002
Aqjangajuk Shaa,
RCA (1937– )
serpentine, antler
15 × 15 × 11½ inches

"Clams are a main source
of food for walrus. The wal-
rus is very happy dancing
with the big catch."

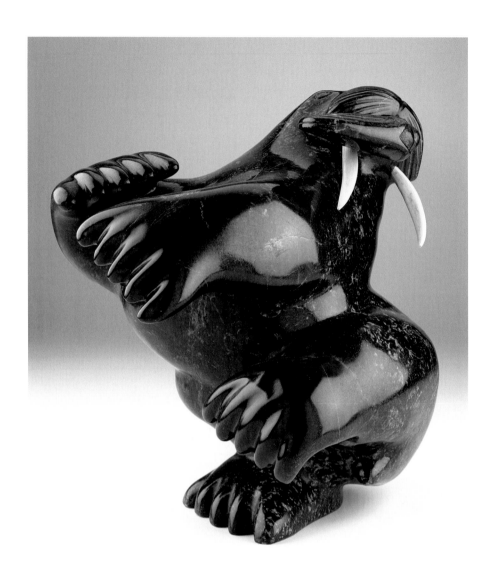

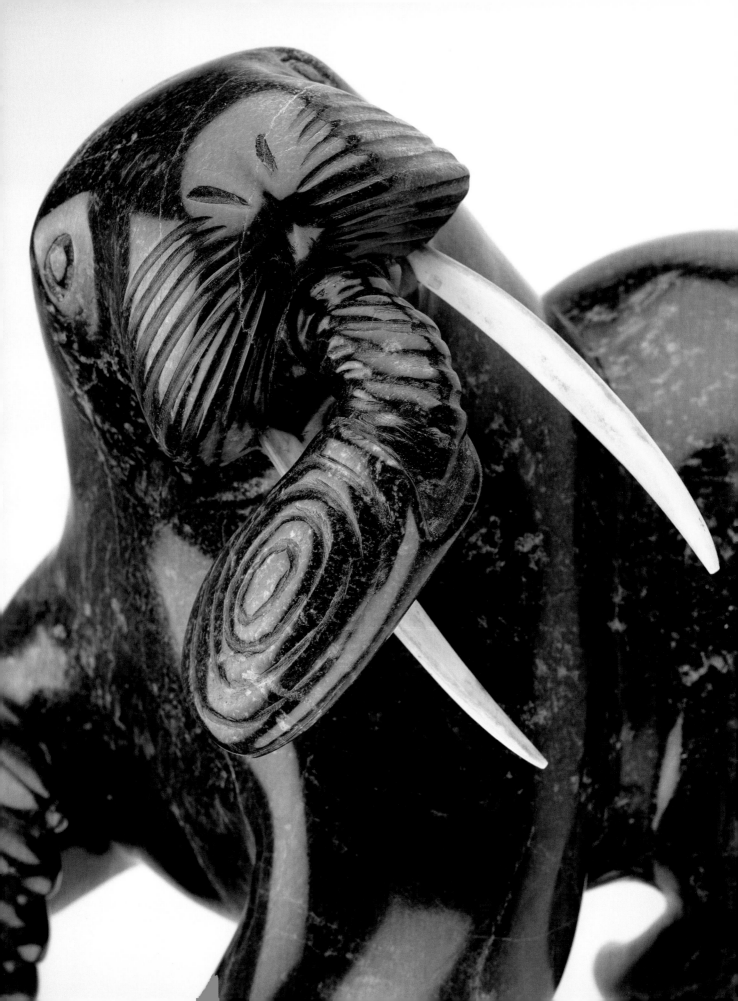

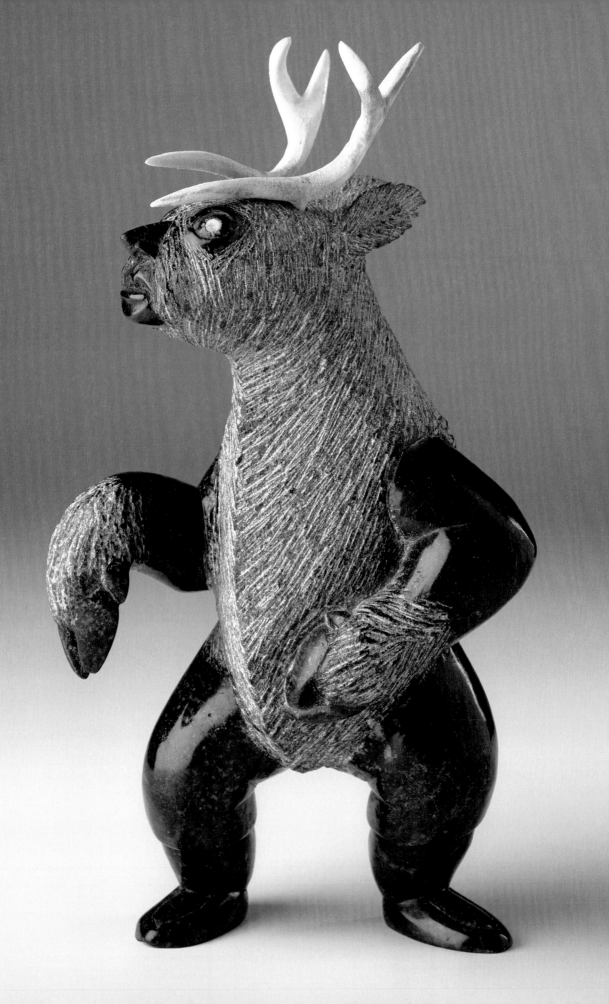

*Facing page:*

**Caribou Shaman** 2001
Isacci Etidloie (1972– )
serpentine, antler · 9¼ × 5 × 6 inches
(excluding antlers)

"I have heard stories of shamans
turning into animals. It has been
said that shamans would sacrifice
themselves in the times of starva-
tion by turning into caribou so they
can be hunted to feed the family."

# BEYOND THE IGLOO

## SHAMANS

## AND SPIRITS

**Walrus Bear Spirit** 2001
Markoosie Papigatok (1976– )
serpentine, ivory
12½ × 16 × 6 inches

"This is a shaman transforming
from a walrus into a polar bear."

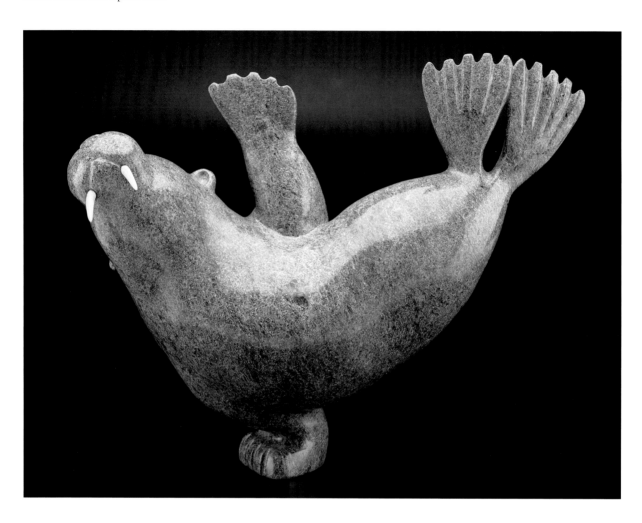

*Facing page:*

**Bird Shaman
Transformation** 2002
Ashivak Adla (1977– )
serpentine · 7½ × 5½ × 2 inches

"This sculpture just hap-
pened. I only had a small
piece of stone and did not
know what I was going to
carve. As I started carving
the stone, it gradually trans-
formed into a ptarmigan,
a goose and the shaman
human forms."

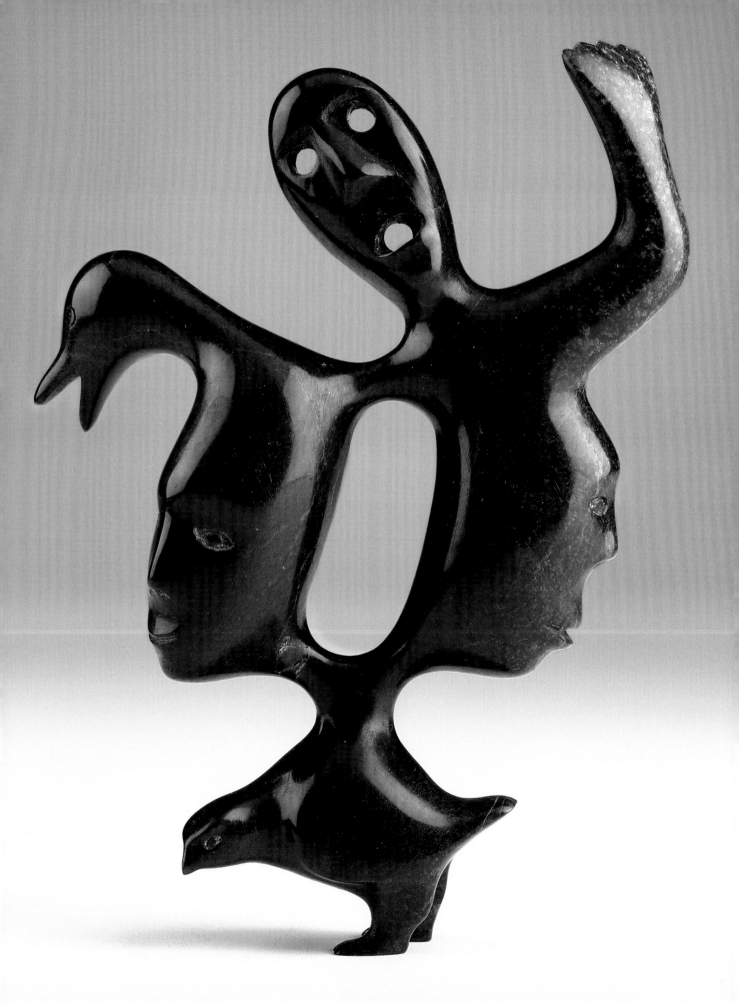

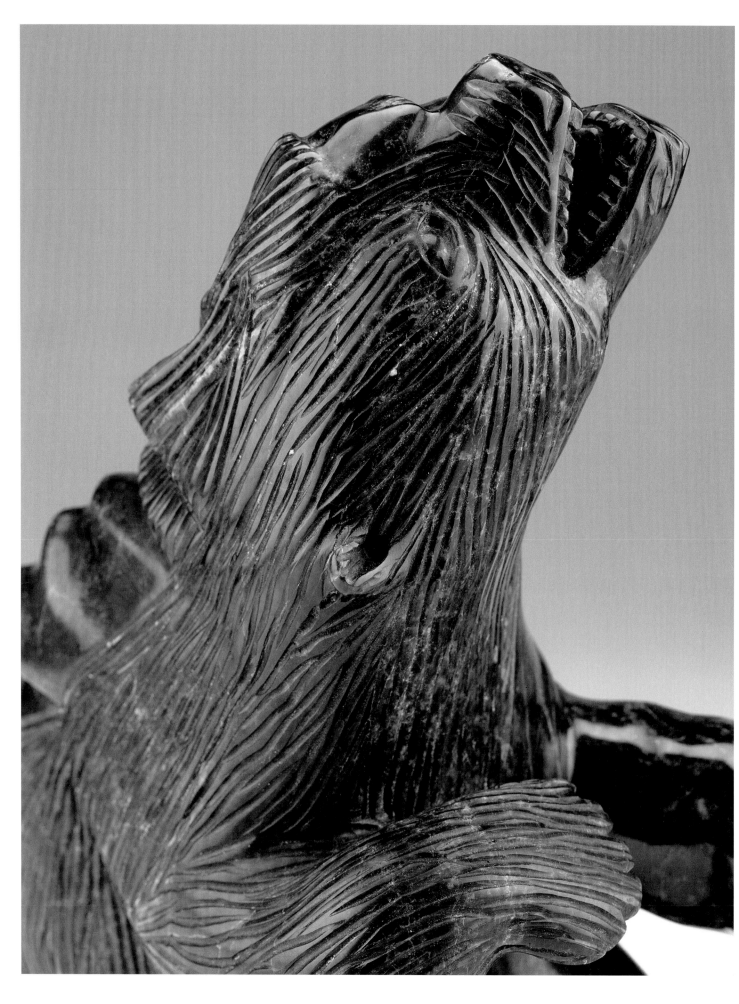

**Shaman Transforming
into a Wolf** 2003
Padlaya Qiatsuk (1965– )
serpentine, caribou hide
shaman 12 × 12 × 7 inches
husky 3 × 7½ × 3

"The shaman is transforming
into a wolf, guided by the
dog helper, to find the cari-
bou herd to eat, to survive,
to avoid starvation."

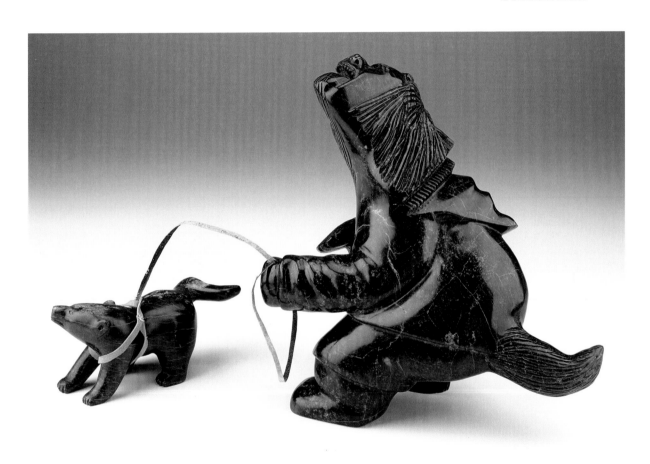

**Transforming
Shaman** 2003
Ashivak Adla (1977– )
serpentine, antler inlay
16 × 8 × 5½ inches

"This sculpture is of a sha-
man transforming into a
wolverine. There are no wol-
verines in Cape Dorset, but
I have seen them on TV. This
is all from my imagination.
The back of the body has
a protruding spine of the
wolverine becoming human.
The spine is made of pieces
of polished caribou antler
that I have inlaid into
the stone."

*Facing page:*

**Shaman's
Celebration** 2002
Quvianatuliak
Takpaungai (1942– )
serpentine, antler
bear 32½ × 16 × 14 inches
walrus 24 × 18 × 8 inches

"The bear and the walrus
were animals used in con-
flicts between powerful
shamans trying to over-
power each other. The
bear and the walrus were
enemies before but became
friends afterwards, and now
they are dancing together."

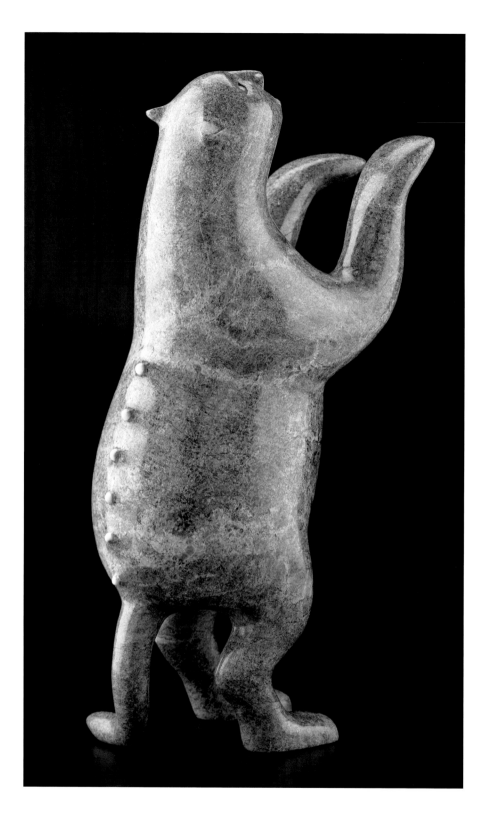

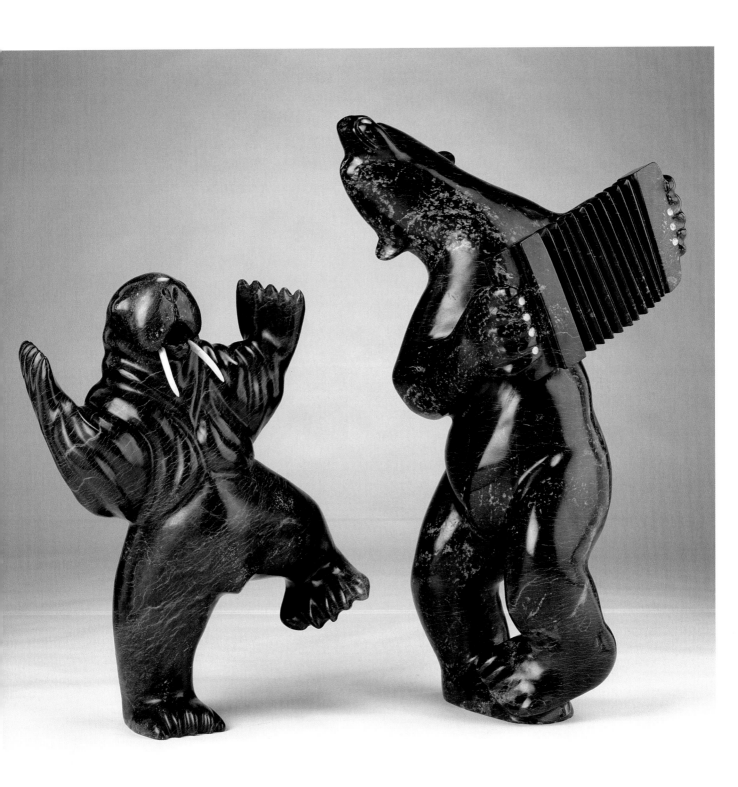

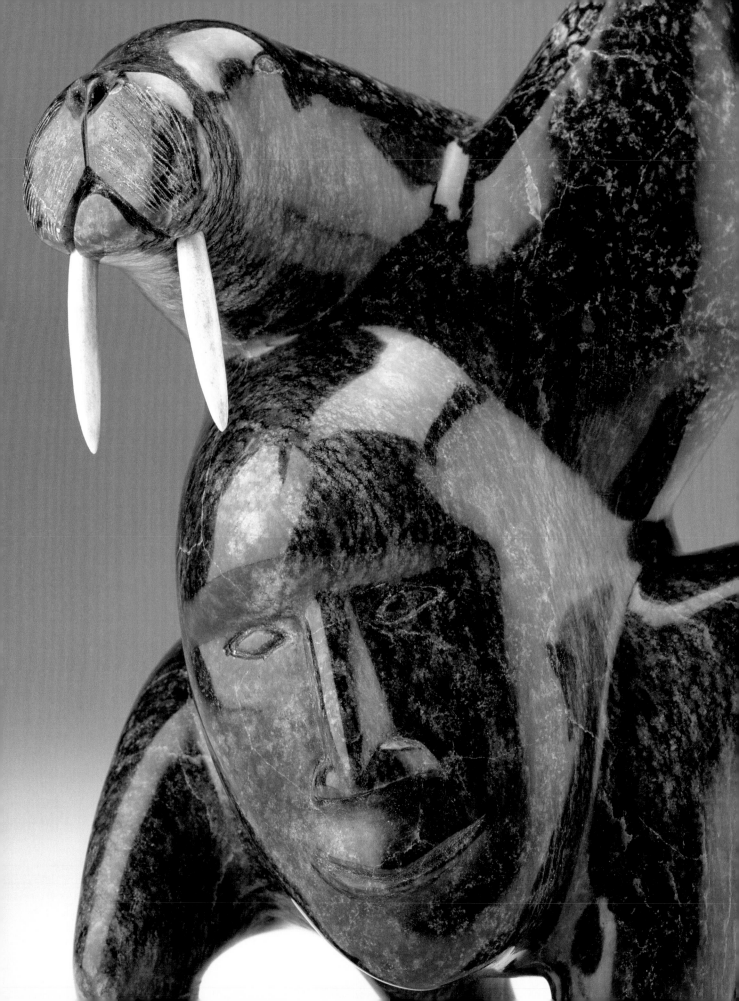

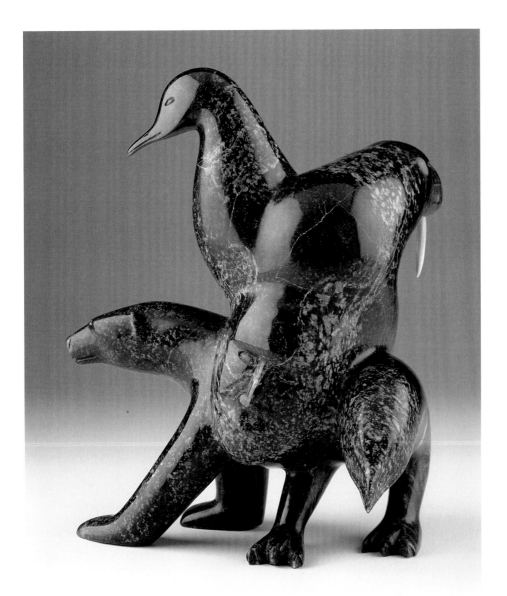

"This carving is of shamans
transforming into Arctic
animals. These shamans are
great hunters calling on
the Arctic animals. There is
a falcon, a great hunter of
the sky; the walrus, a great
hunter of the sea; and polar
bear, a great hunter of the
land—all powerful hunters.
The goose . . . we hunt
them every year and they
taste good!"

**Swimming Sedna
with Kudlik** 2001
Kingwatsiak Jaw (1962– )
serpentine
8½ × 6½ × 2½ inches

"Sedna bringing her oil
lamp to poor elderly out-
casts to keep them warm
in the winter igloo."

*Facing page:*

**Dancing Bear** 2003
Pauta Saila, RCA (1916– )
serpentine, ivory
13½ × 12 × 7 inches

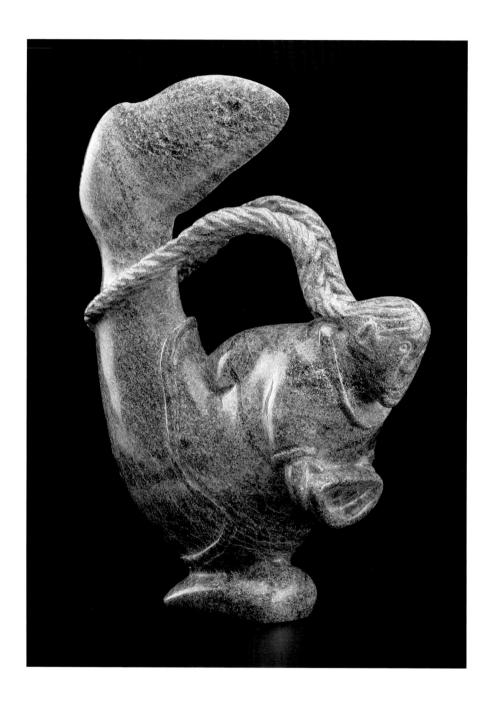

CAPE DORSET SCULPTURE

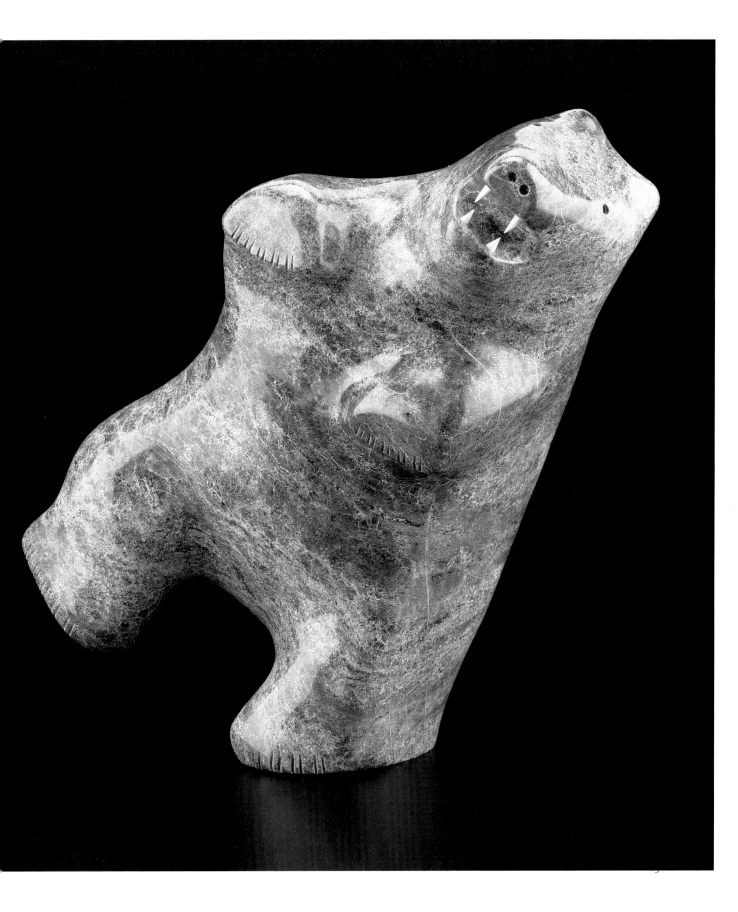

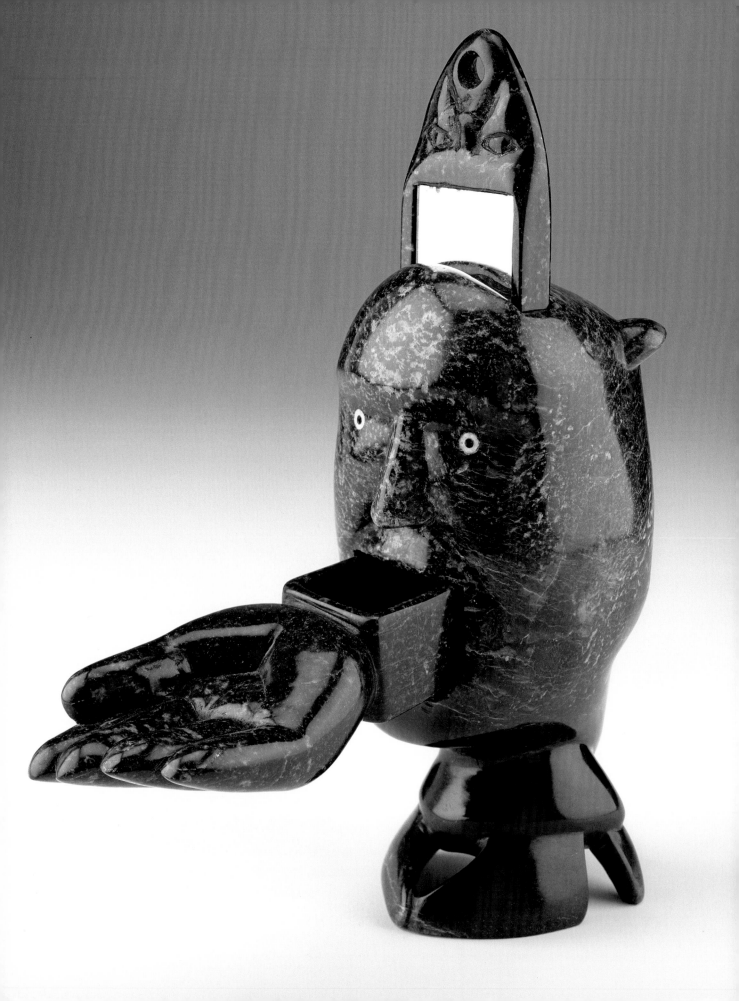

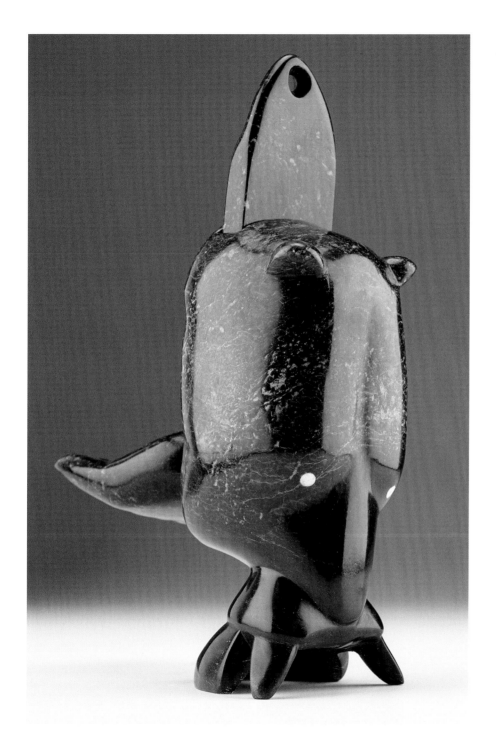

**The Powers of the
Shaman Uniting All** 2002
Isacci Etidloie (1972– )
serpentine, glass, ivory inlay
12 × 9 × 4 inches

"The sculpture shows the
united powers of the sha-
man. The shaman is always
thinking. The hand is ask-
ing for things that it will
take to store in the mind
[drawer]. The mirror is
a reflection of oneself and
it is how he sees you. It is no
different from how one sees
oneself. A spirit helper is
the face around the mirror.
The polar bear [on the back]
is a powerful hunter and
the shaman calls on the
strength of the polar bear,
and the hoof [on the base] is
for the speed of the caribou."

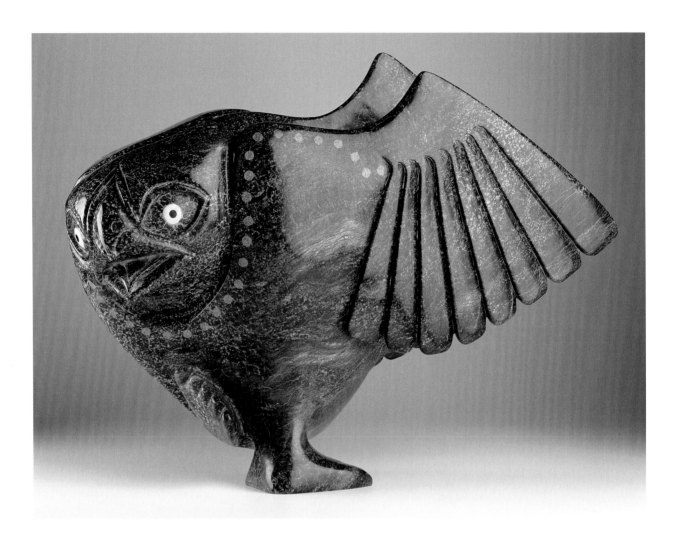

**Shaman Transforming into an Owl** 2002
Toonoo Sharky,
RCA (1970– )
serpentine, ivory inlay
17 × 24 × 6 inches

"If I knew about shamans, I would talk about them more. I say again, I am too young to know about shamanism. There is so much shape and space in the stone to have different ideas, so I let my imagination go to work and get busy with it. So this shaman is old and wise [like an owl]. After being a shaman knowing [all] about the ground, he became wise and old. He wanted to refresh his body, so he became an owl and started soaring around the Arctic."

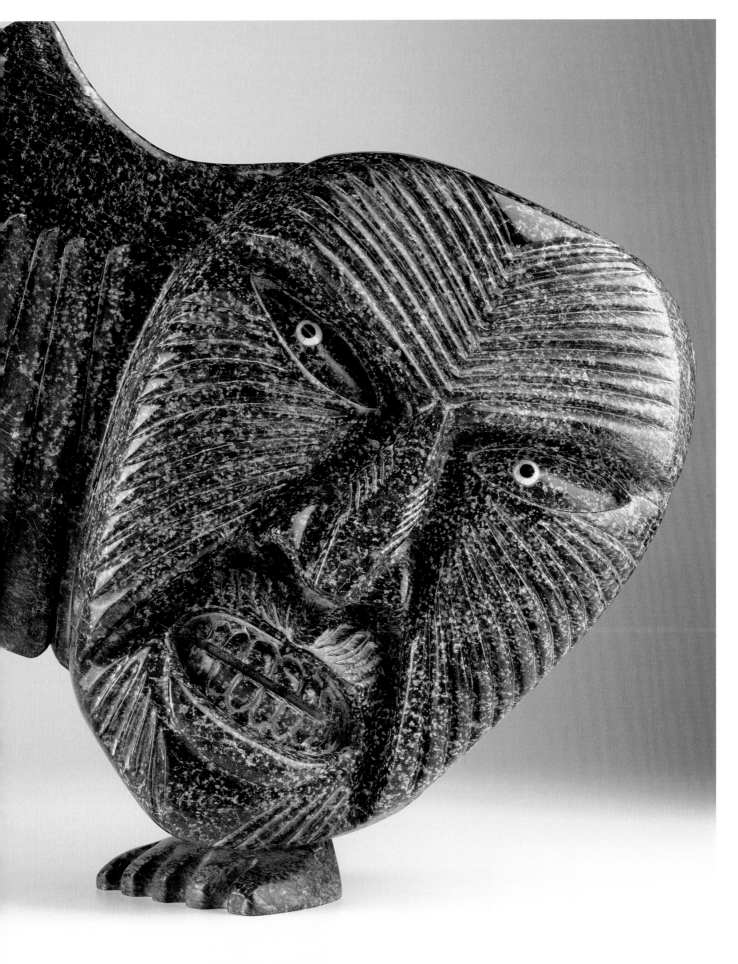

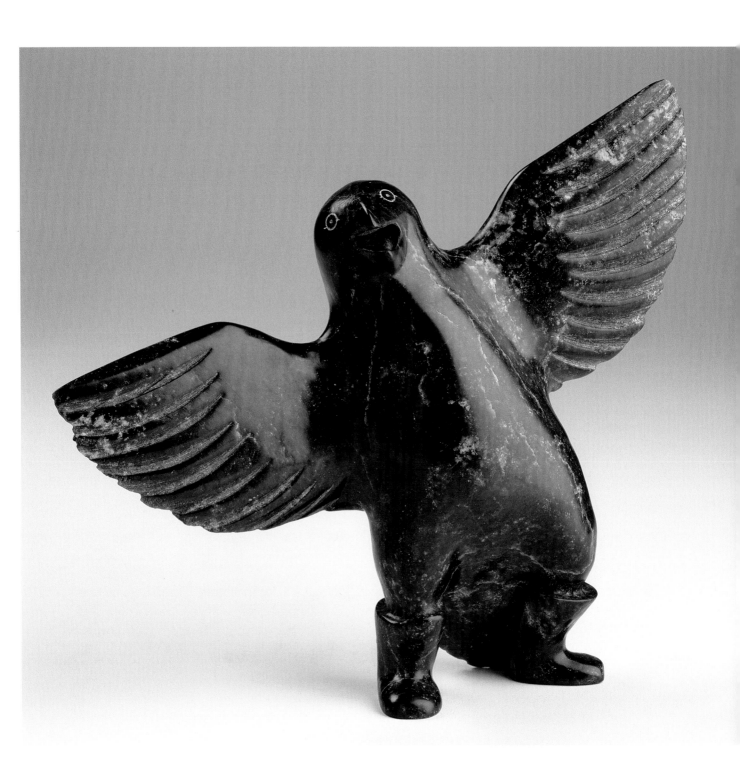

CAPE DORSET SCULPTURE

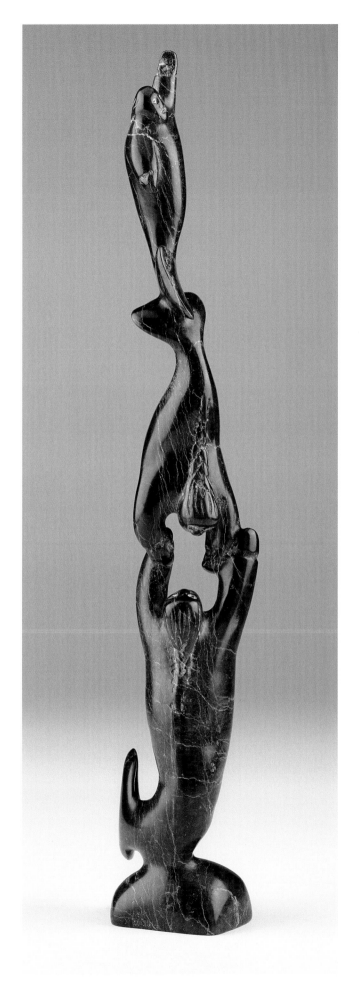

*Facing page:*

**Bird Shaman** 2003
Kellypalik Qimirpik
(1948– )
serpentine
9 × 10½ × 2½ inches

"There are stories of how
the raven and the owl got
their colours. This owl will
be painted by the raven—
and she will then paint the
raven. The owl is shown
with humanlike qualities."

**Sedna Totem** 2001
Kingwatsiak Jaw (1962– )
serpentine · 17 × 3 × 2 inches

"Sedna calling her children
to come home. But the
Sedna boy is too mischie-
vous and wants to explore
the outside world."

**Sedna in the Kelp with
Her Lamp** 2000
Kingwatsiak Jaw (1962– )
serpentine, antler, crystal,
glass inlay · 21½ × 13 × 8 inches

"Sedna waiting for the
wishes of Nunavummiut
[people of Nunavut] with
her precious gifts."

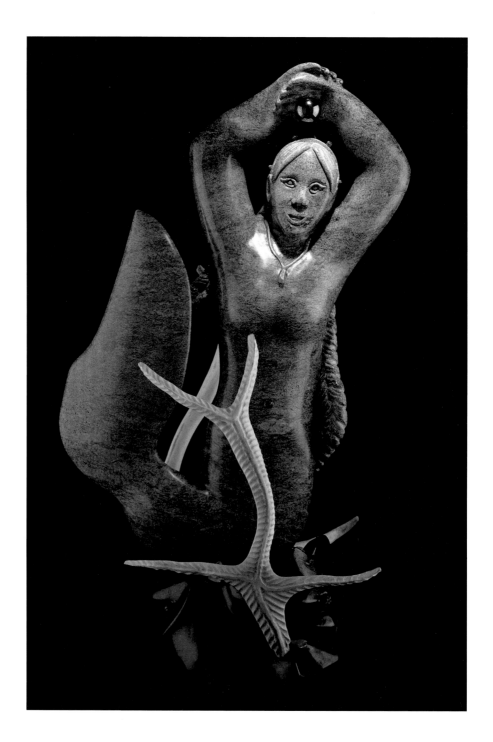

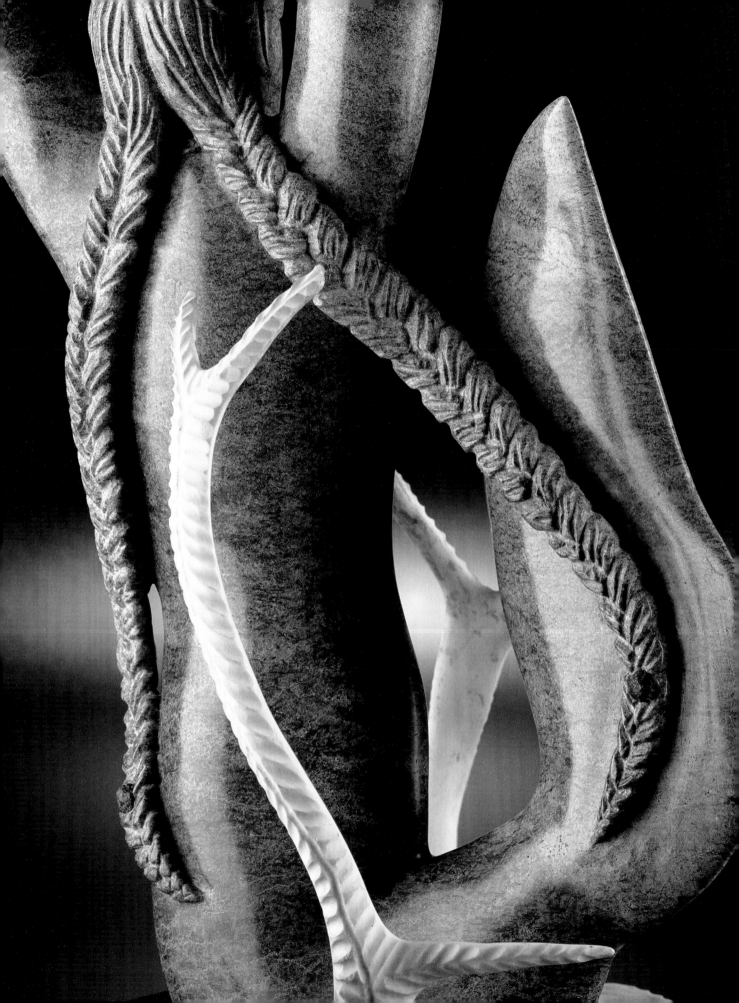

CAPE DORSET SCULPTURE

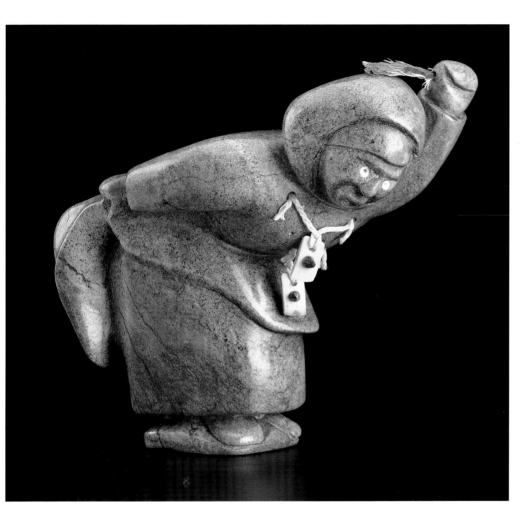

**Shaman Dancing with a Feather** 2001
Omalluk Oshutsiaq
(1948– )
serpentine, antler, feather, garnets
6¼ × 7 × 3½ inches

"She is a shaman dancing in a healing ritual and is holding an eider duck feather to help her in the ceremony. She is wearing decorations of amulets that were traditionally worn on shaman's clothing. For the past three years, I have been saddened by the loss of my son, Aipilie, who was a carver too. This sculpture interprets the mourning for my son. In my dreams, I see a shaman bringing back my son, but I know that will not happen. My daughter, Louisa, collected the raw garnets that are in the front amulets about four years ago some fifty miles from Cape Dorset. She was travelling on the land with other young people in a group learning the old ways in healing."

*Facing page:*

**Wind Chimes** 2000
Arnaquq Ashevak (1956– )
antler, serpentine, steatite, sinew, metal fasteners
18 × 19 × 11 inches

"This is a strange plant with ornaments hanging along its stem to attract some insects, or it could be a plant in your weirdest dream or even a nightmare."

**Shaman, Owl
and Spirits** 2004
Tayaraq Tunnillie (1934– )
serpentine · 6 × 7 × 5 inches

"This carving is of the faces
of shamans, that I have
carved with an axe and chis-
els. It is getting more difficult
for me to carve and to hold
the stone still."

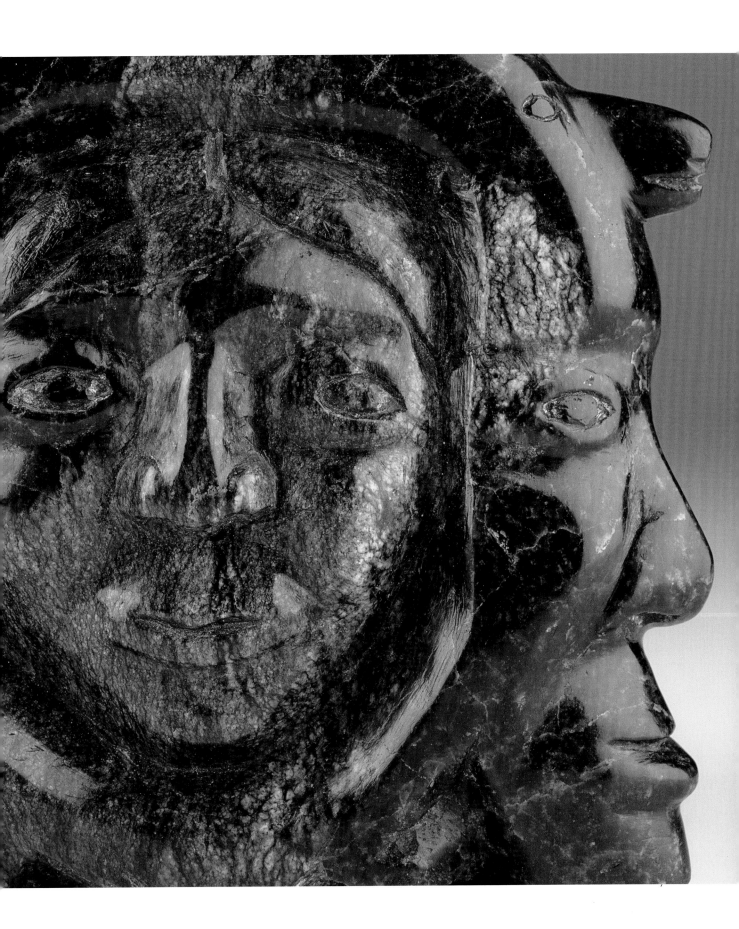

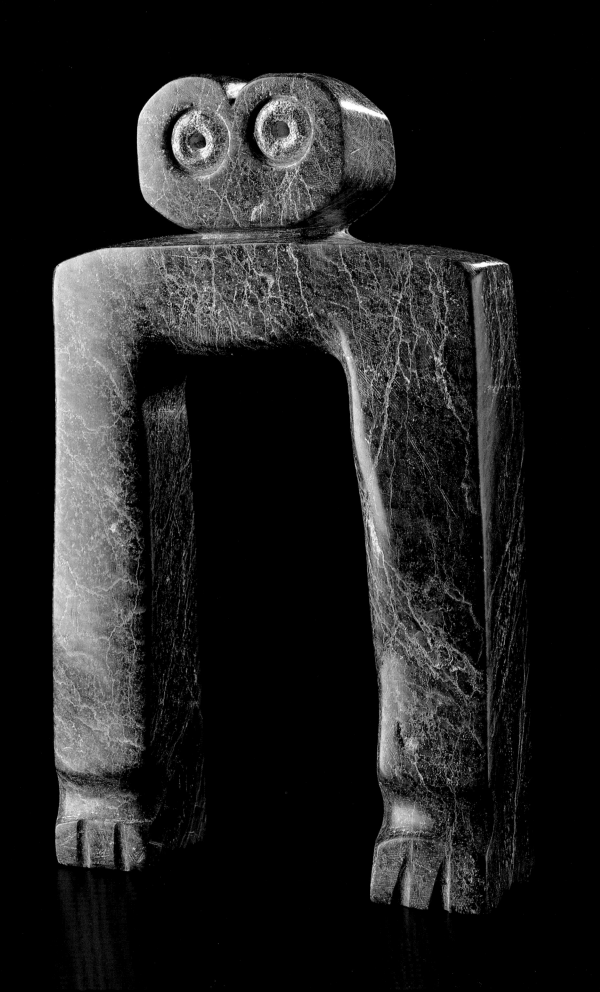

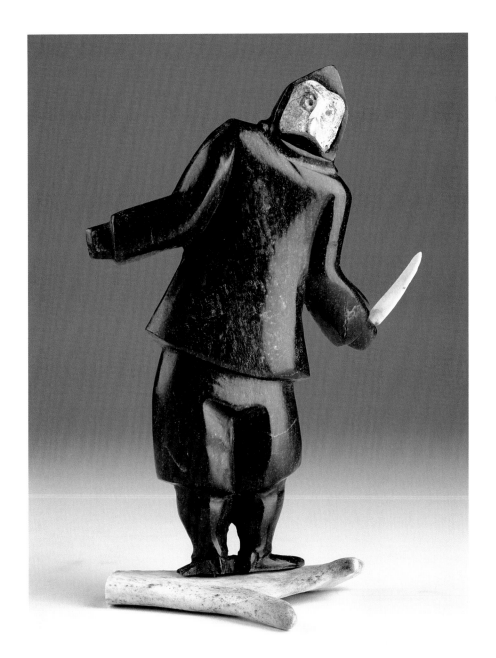

*Facing page:*

**Owl Spirit** 2000
Osuitok Ipeelee,
RCA (1923– )
serpentine · 10 × 6 × 2½ inches

**Owl Shaman** 2002
Samonie Toonoo (1972– )
serpentine, antler, bone inlay
8 × 5 × 3½ inches

"This is a shaman that is
turning into a bird. It has
to turn into one so that
it can see game from the
sky to feed oneself. It has
been lucky and has caught
a fish in its talons."

**Legends** 2003
Kiawak Ashoona,
RCA (1933– )
serpentine, sinew
22½ × 14½ × 10 inches

"These are shamans. These
creatures are married.
The bird creature [with the
young in the hood of the
*amauti*] on the top of the
sculpture is the wife to the
bird husband on the bottom.
She braids a rope. They
live in very high cliffs."

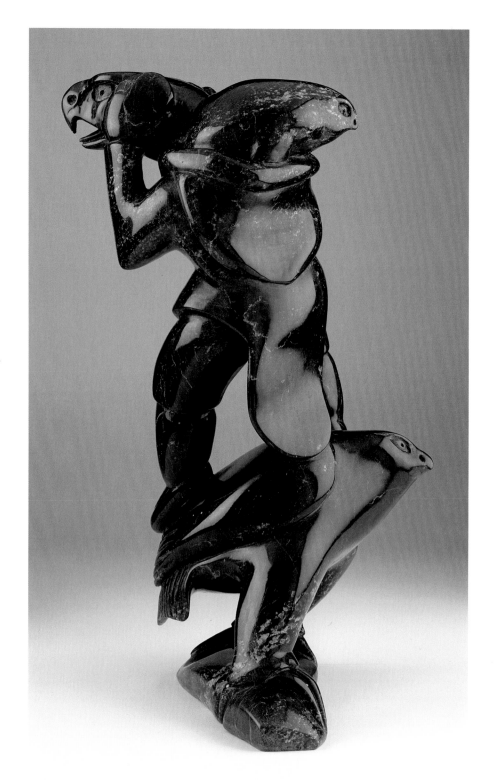

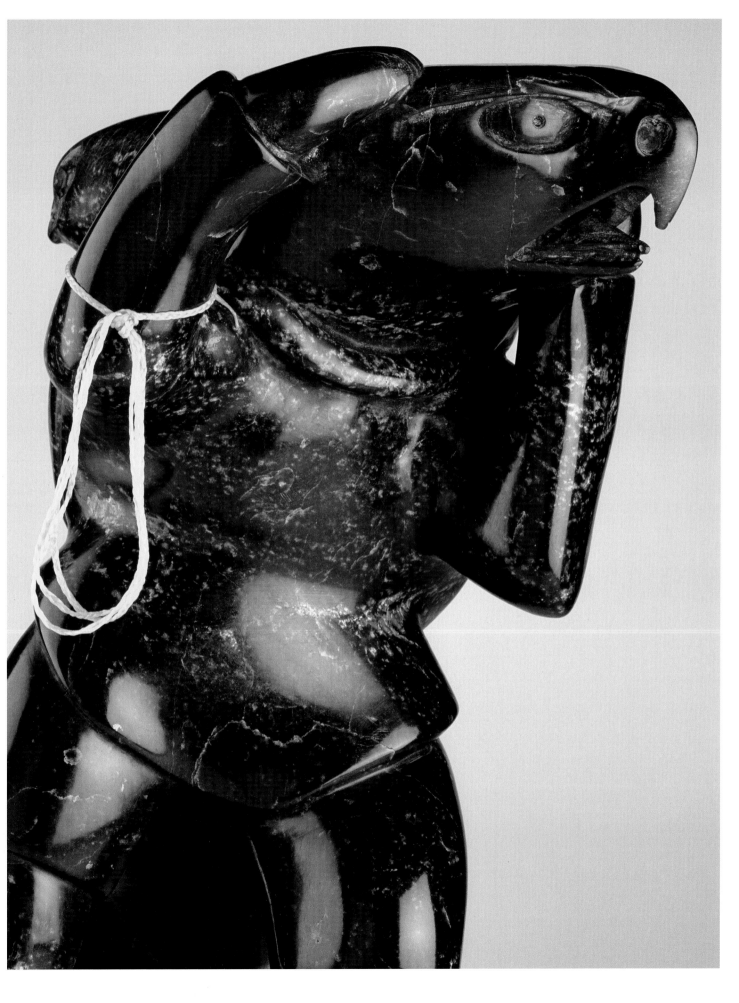

**Spirit Face
Transformation** 2000
Toonoo Sharky, RCA
(1970– )
whalebone, ivory, serpentine
17½ × 16 × 6 inches

"This is a spirit face trans-
forming into an ugly
creature. Very scary—with
a wide mouth, sharp fangs
and a powerful jaw that
can taste big and small bites.
Some are easy to carve,
some are more difficult crea-
ture ideas that come with
and without stories."

**Shaman's
Perspective** 2002
Toonoo Sharky,
RCA (1970– )
serpentine, ivory
8 × 8½ × 2 inches

"As an artist, I used my imag-
ination and used the shape
of the stone as to not waste
the piece. I figured out [that
I should] get busy and make
it into a more interesting
shape. This piece is from
a shaman's perspective,
the difficulty of being a sha-
man with bird feet and a
whale's tail."

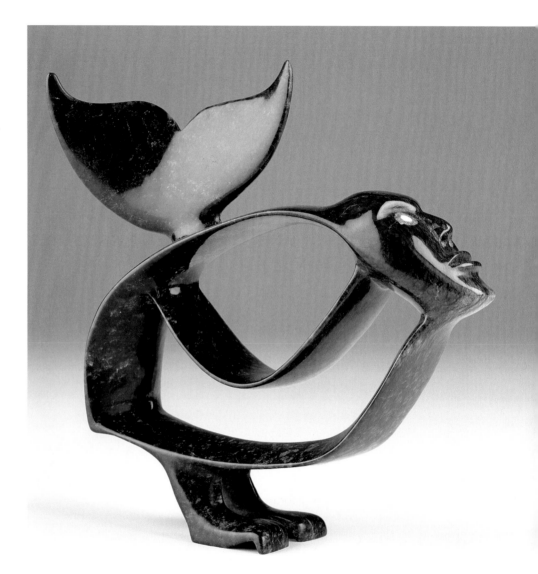

Blodgett, Jean. *Grasp Tight the Old Ways: Selections from the Klamer Collection of Inuit Art.* Toronto: Art Gallery of Ontario, 1983.

Blodgett, Jean. *In Cape Dorset We Do It This Way: Three Decades of Inuit Printmaking.* Kleinburg, Ont.: McMichael Canadian Art Collection, 1991.

Finckenstein, Maria Von, ed. *Celebrating Inuit Art 1948–1970.* Toronto: Key Porter Books, 2000.

Gustavison, Susan. *Northern Rock: Contemporary Inuit Stone Sculpture.* Kleinburg, Ont.: McMichael Canadian Art Collection, 1999.

Hessel, Ingo. *Inuit Art: An Introduction.* Vancouver/Toronto: Douglas & McIntyre/ New York: Abrams, 1998.

Houston, James. *Confessions of an Igloo Dweller.* Toronto: McClelland & Stewart, 1995.

Houston, James. Introduction "Cape Dorset 1951" in *Cape Dorset: The Winnipeg Art Gallery January 12 to March 2, 1980,* by Winnipeg Art Gallery. Winnipeg: Winnipeg Art Gallery, 1979.

*Inuit Art Quarterly* magazine has many informative details on the artists. It's published by the non-profit Inuit Art Foundation, which is governed by a board of Inuit artists.

Macduff, Alistair, and George M. Galpin. *Lords of the Stone: An Anthology of Eskimo Sculpture.* Vancouver: Whitecap Books, 1982.

Roch, Ernst, ed. Texts by Patrick Furneaux and Leo Rosshandler. *Arts of the Eskimo: Prints.* Montreal: Signum Press / Toronto: Oxford University Press, 1974; Barre, Mass.: Barre Publishers, 1975.

*Sedna: The Making of a Myth.* VHS (60 min.) Directed by John Paskievich. National Film Board of Canada, 1992. Order no. 1-0192-006. This is a documentary on the George Pratt sculpture project and shows the Andrew Gordon Bay quarry.

**ASHIVAK ADLA** (1977– )  Ashivak's parents are Kumaarjuk and David Adla, and both of his grandfathers, Aoudla Pee and Kulai Adla, were well-known carvers. When Ashivak was eleven, he started working with Aoudla Pee's carving tools. He says that he learned from watching Nuna Parr and his son, Jutani, as they worked on their bear sculptures, though at the time, Ashivak already was already fascinated by birdlife. He has been exhibiting since 1988. His brothers Etidloi and Mappaluk are also carvers.

**ETIDLOI ADLA** (1982– )  Etidloi is a son of Kumaarjuk Adla Pii and David Adla. His two brothers, Ashivak and Mappaluk, are also carvers. This is Etidloi's debut in a publication.

**ULAIGGII ADLA** (1980– )  Ulaiggii's parents are Nuvualia Parr and Seema Adla. This is the first time that Ulaiggii's work has appeared in a publication.

**SUQUALUK AKESUK** (1959– )  Suqualuk is the adopted son of artists Simaiyok and Latcholassie Akesuk. He lives between Iqaluit and Cape Dorset, and creates sculptures that feature birdlife and sea mammals, both of which he treats in a fluid manner. He began exhibiting in 1979 and has been in five group shows.

**ADAMIE ASHEVAK** (1959– )  Adamie is a son of the noted artists Kenojuak and Johnniebo Ashevak. He began carving when he was ten, learning from his parents, but did not carve regularly until recently. Early on, he loved to carve bears, but he has also made figurative works. He credits Nuna Parr for his ideas and support towards his wildlife subjects, and artist Silas Kayakjuak for advice on how to treat the human figure. He has been exhibiting since 1987 and was part of the "New Visions" show in 1996.

**ARNAQUQ (ANNAGO) ASHEVAK** (1956– )  Arnaquq is an adopted son of the noted artists Kenojuak and Johnniebo Ashevak. He began carving in the early 1980s. In 1990, he started working as an assistant printmaker for the West Baffin Eskimo Co-operative, which inspired him to make the drawings that led to recognition as a graphic artist. He is more widely known as a carver and enjoys making fanciful constructions that use a variety of materials. He first exhibited as a printmaker in 1982, and as a sculptor two years later.

**KENOJUAK ASHEVAK,** RCA (1927– ) Kenojuak Ashevak was among the first women to participate in the arts projects in Cape Dorset and contributed to the first release of Inuit prints in 1959. She was in the important "Sculpture/Inuit. Sculpture of the Inuit: Masterworks of the Canadian Arctic" exhibition (1971–73) that toured the world, and she is still a major force in the art of Cape Dorset (and of the Arctic). Few Canadian artists have received more honours for their achievements: she was elected to the Royal Canadian Academy, appointed to the Order of Canada (later a Companion) and awarded many honorary doctorates. Three of Kenojuak's images appeared on Canadian postage stamps, and her 1960 print, *The Enchanted Owl,* is an icon of Canadian art, appearing in numerous publications and on a Canadian stamp. Thanks to her income as an artist, she raised eight children, as well as adopting and raising another eight, and also supports many families.

**KIAWAK ASHOONA,** RCA (1933– ) Kiawak was the fourth son of the noted tribe leader Ashoona, who helped to form the village of Cape Dorset when he brought his hunting group in off the land and settled there, at around the same time as Pootoogook and Saila. Kiawak's mother was the legendary graphic artist Pitseolak Ashoona, RCA. All six of her surviving children made art, though Kiawak may be the finest figurative carver of his generation. His *Tornaaq and Young* was selected as the cover image for the catalogue of the famous 1971–73 exhibition "Sculpture/Inuit. Sculpture of the Inuit: Masterworks of the Canadian Arctic" that toured internationally. His works have been widely exhibited and collected around the world. He was appointed to the Order of Canada in 2000 and elected to the Royal Canadian Academy in 2003.

**MAYUREAK ASHOONA,** RCA (1946– ) A daughter of noted graphic artist Sheouak Parr, who was one of the first women to participate in the early drawing projects in the 1950s, Mayureak grew up traditionally on the land. She became the partner of artist Qaqaq Ashoona, and started drawing and carving in the early 1960s, though her graphics were not shown until later. After Qaqaq's death in 1996, Mayureak moved back to Cape Dorset from their outcamp and began to produce work that was stylistically more in accord with her own interests and that were often on a larger scale. In 2003, she was elected to the Royal Canadian Academy.

**OHITO ASHOONA** (1952– )  The son of artists Mayureak and Qaqaq Ashoona, Ohito learned to carve from his father and from his uncle, Kiawak Ashoona. Ohito began carving when he was about twelve, and his love for the land is evident in his work, which features a wide range of wildlife. Ohito's competence on the land qualified him for accreditation as a Level 1 Outfitting Guide, a rare achievement for an Inuit hunter. In 2002, he received the National Aboriginal Achievement Award for the Visual Arts.

**ISACCI ETIDLOIE** (1972– )  Isacci is the son of carver Etulu Etidlui. His grandparents Etidlooie Etidlooie and Kingmeata Etidlooie were noted graphic artists and sculptors in the early days of Cape Dorset art. Isacci has been carving since he was seven, and his favourite subjects are generally people engaged in activities, whether fishing or drumdancing, always with a sense of motion. Recently, he has been making elaborate containers that incorporate both figurative elements and a whimsical sense of humour.

**OSUITOK IPEELEE**, RCA (1923– )  Osuitok grew up traditionally on the land and learned to carve by watching his father, Ohotok. He sold his first ivory carving in the 1940s and was already highly regarded for his artistry by the time that he met James Houston in 1951. Osuitok participated in the introduction of the printmaking program in the late 1950s, and his work was in the "Sculpture/Inuit. Sculpture of the Inuit: Masterworks of the Canadian Arctic" show (1971–73) that toured the world. His sculptures gradually became more stylized and minimal; by the late 1980s, his austere renderings of caribou were more symbol than depiction. With the onset of Parkinson's, Osuitok could no longer produce sculpture at the level of his classic work, but his simpler imagery is a logical progression of where his artistic direction was taking him before the disease. Historically one of the most influential Inuit sculptors, his work is in international collections, including the National Gallery of Canada, the Metropolitan Museum of Art in New York and the Vatican Collection. In 2004, Osuitok received the Lifetime Aboriginal Art Achievement Award.

**KINGWATSIAK (KING) JAW** (1962– ) King is a son of master carver Joe Jaw and the younger brother of Mathew Saviadjuk, Pootoogook Jaw and Salomonie Jaw, all excellent carvers and each with quite different interests and styles. King started carving when he was about eight but did not take it up seriously until his early thirties. He worked in the mine at Nanasivik, where he became an industrial mechanic, and today is seasonally employed as a certified carpenter. He credits his brother Pootoogook as an influence on his carving.

**POOTOOGOOK JAW** (1959– ) One of the three sculptor sons of master carver Joe Jaw, Pootoogook has been carving from an early age. He uses a wide range of subjects in his work, and his style varies depending on the nature of the stone that he is dealing with. At times, his sculptures have multiple figures interacting and are almost obsessively detailed; at other times, particularly when working with very hard stones, his work is simpler and more iconic. His quiet sense of humour often surfaces in his work.

**JOANASSIE MANNING** (1967– ) Joanassie, who began carving at the age of twenty, credits his grandfather, the renowned carver Osuitok Ipeelee, as a great influence on his work. After carving sporadically for a number of years, Joanassie is now working more consistently. He has evolved a personal style that is becoming stronger and more confident.

**JOHNNYSA MATHEWSIE** (1984– ) Johnnysa is the son of Qiatsuk Qiatsuk and a grandson of the master carver Lukta Qiatsuk. It is early days for Johnnysa as a carver, but his work is starting to attract notice in the south. He is adept at both wildlife and figurative carvings.

**QAUNAQ MIKKIGAK** (1932– ) A daughter of graphic artist Mary Kudjuakjuk, Qaunaq grew up traditionally on the land and began to make small carvings after her father's death when she was still a girl. She married Oqutaq Mikkigak; both of them were encouraged by James and Alma Houston to make carvings. Qaunaq made some drawings in 1960 and in the late 1970s but preferred carving. As both Qaunaq and her husband had wage employment, she made carvings because she wanted to, not because she had to, and perhaps because of this, her work has a certain charm.

**PITSEOLAK NIVIAQSI** (1947– )  A son of the great sculptor and graphic artist Niviak-siak and the graphic artist Kunu, Pitseolak trained as a printmaker, possibly through the influence of his older brother, Qiatsuq. As a sculptor, Pitseolak has a talent for using positive and negative space that imbues his work with a lightness and fluidity reminiscent of the work of the two great masters Osuitok Ipeelee and Lukta Qiatsuk. His work has a wide range: graceful interpretations of wildlife, particularly birds; family carvings, which often represent his wife and children; and depictions of the sea goddess. His future as a master carver and mentor to the new generation of carvers seems assured.

**TAQIALUK (TUK) NUNA** (1958– )  Tuk is a son of carver Sharky Nuna, who was killed in a boating accident while walrus hunting in 1979. After learning to carve by watching his father, Tuk made his first works when he was eight. He became more serious about carving in his late twenties and today carves when he is not out hunting. His rounded comfortable style suits the animal and human subjects that so interest him.

**OMALLUK OSHUTSIAQ** (1948– )  Omalluk was adopted and raised by the artists Etidlooie Etidlooie and Kingmeata Etidlooie. She has been working at both sculpture and drawings for many years, and has exhibited widely. Her work is often smaller in scale, with a fluid curvaceous style.

**MARKOOSIE PAPIGATOK** (1976– )  Markoosie began carving as a teenager and is largely self-taught. His mother, Komajuk Tunnillie, and grandparents Tayaraq and Qavaroak (Kabubuwa) Tunnillie, were all accomplished carvers. Markoosie works mainly with animal themes, which he treats with a characteristic whimsy.

**NUNA PARR** (1949– )  Nuna was born near Cape Dorset and lived with his adoptive parents, the graphic artists Parr and Eleeshushe. The family moved to Cape Dorset in 1960, after Parr was injured in an accident, and the young Nuna started carving while he was still in school. His interest in hunting and his regard for the animal life of the Arctic are directly reflected in his work. Nuna's rounded forms have great movement and a natural flow with the grain of the stone, as if both were made for each other. He has been carving for forty years, and his work continues to be shown nationally and internationally.

**EYEETSIAK PETER** (1937– )  Eyeetsiak has been making art since he was a teenager and is credited as a printmaker in the 1961 Cape Dorset print release. In 1970, he received first prize for his sculpture *Taloolayook and Man* in the Northwest Territories Centennial Sculpture Competition (the piece was presented to HRH Queen Elizabeth II). His sculpture from the early 1960s already had the fluidity of line and use of cutaway that are now characteristic of his work. He was part of the 1980 "La déesse inuite de la mer/The Inuit Sea Goddess" touring exhibition originated by the Musée des beaux-arts de Montreal, and his work is exhibited nationally and internationally.

**JAMASEE PADLUQ PITSEOLAK** (1968– )  Jamasee is the son of carver Oopik Pitsiulak and Mark Pitseolak (who is the son of the noted Peter Pitseolak).

**KANANGINAK POOTOOGOOK,** RCA (1935– )  A son of tribe leader Pootoogook, Kananginak trained in 1957 as one of the first printmakers, and since then he has contributed to virtually every Cape Dorset annual print release. He is famous for his careful renderings of birds, which earned him the nickname "Audubon of the Arctic." He was included in the important 1971–73 international touring show "Sculpture/ Inuit. Sculpture of the Inuit: Masterworks of the Canadian Arctic." Recently, he embarked on a series of detailed narrative drawings that depict both traditional and contemporary Inuit life. He has received many honours, including election to the Royal Canadian Academy in 1980. His work is widely exhibited and held in many national and international collections, including the National Gallery of Canada and the Metropolitan Museum of Art in New York.

**PAULASSIE POOTOOGOOK,** RCA (1927– )  Paulassie is the eldest of the four sons of the noted tribe leader Pootoogook, who was so pivotal to the formation of the village of Kinngait (Cape Dorset) in the early days. The four brothers, Paulassie, Eegyvudluk, Kananginak and Pudlat (and many of their wives and children), are all well-known artists at both a national and international level. Paulassie began as a printmaker but has been carving for almost fifty years now, and his work reflects an ongoing interest and curiosity in the world around him.

**LUKTA QIATSUK** (1928–2004)  Lukta and his father, Kiakshuk, were both featured in the famous "Sculpture/Inuit. Sculpture of the Inuit: Masterworks of the Canadian Arctic" touring exhibition (1971–73). His sister, the graphic artist Paunichea, is the mother of Aqjangajuk Shaa. Lukta's three sons (two of whom are in this book) are also strong and innovative carvers. Since the 1950s, Lukta was an important figure in the art of Cape Dorset, gaining recognition as a sculptor, a graphic artist and a printmaker (he trained in the beginning days in 1957–58). He was the main printer for more than two hundred graphics, including a good number of the most highly esteemed images. As a sculptor, he liked both figurative and wildlife subjects, and had an interest in birds, particularly owls.

**PADLAYA QIATSUK** (1965– )  One of the three sons of master carver Lukta Qiatsuk, Padlaya began carving at the age of twelve and credits his father and other elder carvers as influences. From his father, he learned a deep respect for the land, and this admiration shows in his treatment of wildlife subjects. He says that he has fun making art, and he likes to carve figurative works, with transformational themes being his favourites.

**POOTOOGOOK QIATSUK** (1959– )  Pootoogook learned to carve from his master carver father, Lukta, and has been sculpting for many years. He was also a printmaker for eight of the Cape Dorset annual print collections and studied in the jewellery program at Nunavut Arctic College in Iqaluit. Pootoogook has exhibited widely and was included in the 1989 "Masters of the Arctic: An Exhibition of Contemporary Inuit Masterworks" that toured for many years.

**KELLYPALIK QIMIRPIK** (1948– )  Kellypalik has been exhibiting since the mid-1970s and was included in the 1989 "Masters of the Arctic: An Exhibition of Contemporary Inuit Masterworks," which toured for more than a decade. He shows widely nationally and internationally, and has had a number of solo exhibitions. Although known for his carvings of bears and other wildlife, he also sculpts figurative subjects and particularly enjoys transformational themes.

**EMATALUK SAGGIAK** (1955– ) The son of two artists, Lizzie and Saggiak Saggiak, Emataluk started to carve in the early 1970s and credits his father as an influence. In 2002, Emataluk worked as a printmaker for the Cape Dorset annual print release.

**MIKISITI SAILA** (1939– ) The son of legendary artist Pauta Saila, Mikisiti has been exhibiting for more than thirty-five years. His preferred theme is wildlife presented in a minimal but austerely graceful and elegant style.

**PAUTA SAILA**, RCA (1916– ) Pauta was born in the camp of his father, the tribe leader Saila, at Kilaparutua near what is now Cape Dorset. He grew up on the land and began carving as a teenager, making implements and tools from ivory. Later, he carved narrative camp and hunting scenes. Pauta moved to Cape Dorset after marrying his second wife, Pitaloosie, and by the early 1960s was contributing to the annual print release. His work was in the famous 1971–73 "Sculpture/Inuit. Sculpture of the Inuit: Masterworks of the Canadian Arctic" exhibition that toured the world. He was one of the first to see the strengths of developing an idiosyncratic, personally autographic style. Although he has worked on a wide variety of themes during his career, he is most famous for his depictions of dancing bears. After a lifetime of exhibitions and accolades, Pauta was elected to the Royal Canadian Academy in 2003.

**MATHEW SAVIADJUK** (1950– ) Mathew is the eldest of the four sons, all sculptors, of carver Joe Jaw. He is a more than capable hunter, a natural leader and an outstanding artist. His favourite themes embrace wildlife of the natural world and subjects from the spirit world, which he portrays with an awareness of the power that both exude. He has bridged the gap between two cultures and is a man of the new North: he was director of the West Baffin Co-operative for a number of years, served on several regional boards that ultimately led to the formation of the new territory of Nunavut and is at present the mayor of Cape Dorset. Mathew is one of the leading artists and a spokesman for his generation in Cape Dorset, and one of the key mentors for the younger generation of carvers in his community.

**AQJANGAJUK SHAA**, RCA (1937– ) A grandson of the carver Kiakshuk and the only child of artists Paunichea and Munamee Davidee, Aqjangajuk began carving at the age of seventeen. He participated in the early drawing projects in Cape Dorset but realized his strengths lay in sculpture and did not draw after 1960. Only one graphic by him, *Wounded Caribou,* was ever released, in the 1961 Cape Dorset annual print collection. His work was in the famous 1971–73 touring exhibition "Sculpture/Inuit. Sculpture of the Inuit: Masterworks of the Canadian Arctic." Since 1970, he has had eleven solo exhibitions, as well as appearing in many group shows, and his work is in many major museum collections, including the National Gallery of Canada and the Metropolitan Museum of Art in New York. He was elected to the Royal Canadian Academy in 2003.

**PUDLALIK SHAA** (1965– ) Pudlalik is one of the sons of noted sculptor Aqjangajuk Shaa. Pudlalik made his first carving when he was twelve and has been carving ever since. He learned by watching the generation of carvers who, like his father, used axes to work on their pieces. Pudlalik still uses an axe on occasion, though he also uses more modern tools. He has incorporated elements of the dynamic fluid line of his father's work into his own sculptures.

**NAPACHIE SHARKY** (1971– ) Napachie's father, Josephee Sharky, and grandfather Sharky Nuna, were drowned at the same time in 1979. His mother is Ragee Killik-tee, a carver and the daughter of master carver Kuppapik Ragee; his older brother, Toonoo Sharky, is also a carver. Despite all these influences, Napachie has evolved his own style. His interest in the world around him is evident in his range of subjects, but he is best known for his carvings of birdlife, for which his open, delicate style is ideally suited.

**TOONOO SHARKY**, RCA (1970– ) Toonoo's parents, Josephee Sharky and Ragee Killiktee, were both carvers, though he credits his grandfather, master carver Kup-papik Ragee and his uncle Shorty Killiktee as influences. Toonoo started carving at ten, began to get serious at thirteen and first exhibited when he was just seventeen. He is regarded as one of the most exciting young carvers to emerge in the Arctic. His themes include fanciful and quite dramatic treatments of wildlife, particularly

birds, and transformational works that are both powerful and humorous. His work is widely shown, and he was elected to the Royal Canadian Academy in 2003.

**QUVIANATULIAK (KOV) TAKPAUNGAI** (1942– ) Kov was one of the youngest artists to be selected for the important exhibition "Sculpture/Inuit. Sculpture of the Inuit: Masterworks of the Canadian Arctic," which toured the world in 1971–73. He has continued to produce work that is both powerful and memorable, often on a large scale. He is a keen hunter, and his respect for the land shows in his carvings of wildlife, but his wide-ranging sculptures include figurative and transformational themes. His work has been widely exhibited.

**JUTAI TOONOO** (1959– ) Jutai and his sister, the renowned artist Oviloo Tunnillie, both learned to carve by watching their father, Toonoo Tunnillie. Jutai began carving at the age of seven. After working as an artist for a number of years, by the early 1980s he decided that he could earn more in an office position, but he resumed carving in the early 1990s. His language skills and succinct conceptualization of ideas merge in sculptures that challenge perceptions and notions of what art is supposed to be about.

**SAMONIE TOONOO** (1972– ) Samonie is a son of the graphic artist Sheojuk and the carver Toonoo Tunnillie, and the younger brother of sculptors Oviloo Tunnillie and Jutai Toonoo. Samonie began carving in his early twenties, making realistic depictions of wildlife and figurative subjects; now, he tends towards expressing social issues or images that give sculptural shape to more abstract concepts that we all think about but rarely visualize.

**ASHEVAK TUNNILLIE** (1956– ) The son of Tayaraq and master carver Qavaroak (Kabubuwa) Tunnillie, Ashevak has a style that embraces, but is distinct from, his father's. His work embodies a fluid sense of movement and incorporates the inner nature of the particular stone. Skilled at carving in the round, Ashevak's use of positive and negative space gives his sculptures an openness of design and a strong presence. His work was included in the 1989 "Masters of the Arctic: An Exhibition of Contemporary Inuit Masterworks," which toured for more than a decade.

**OVILOO TUNNILLIE, RCA** (1949– ) Oviloo is the child of two artists, Sheojuk and Toonoo Tunnillie. She grew up traditionally on the land, but like many Inuit of that era, was hospitalized in the south for tuberculosis. Having watched her father carve, she took an early interest in working in stone and sold her first sculpture in 1965. She says that she really began to carve when she had children, to earn money to buy milk for them. Her works often deal with her memories of the TB wards and the south, as well as larger social concerns, particularly those that affect women. Oviloo also is one of the few Inuit artists to choose the nude as a subject. After thirty years of exhibiting, she is regarded as the most accomplished female carver of her generation. She was elected to the Royal Canadian Academy in 2003.

**TAYARAQ TUNNILLIE** (1934– ) The wife of the noted sculptor Qavaroak (Kabubuwa) Tunnillie, Tayaraq is an accomplished carver in her own right and has exhibited since 1970. She also participated in the early drawing experiments at Cape Dorset and has made drawings ever since.